AS WE WERE

American Photographic Postcards
1905–1930

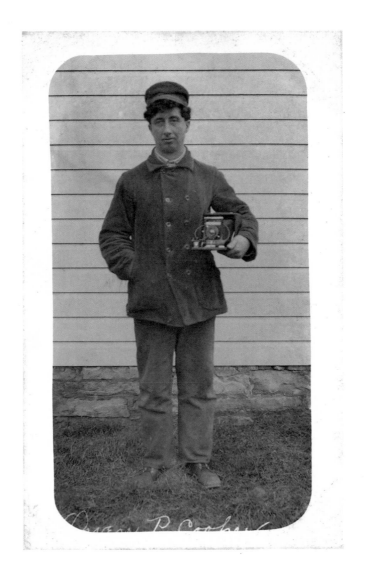

1910—1918.

AS WE WERE

American Photographic Postcards

1905–1930

Rosamond B. Vaule

Foreword by Richard Benson

David R. Godine, Publisher

· BOSTON ·

To my Ohio forebears
and those who helped open my eyes
to early photography

—◆——

First published in 2004 by
DAVID R. GODINE · *Publisher*
Post Office Box 450
Jaffrey, New Hampshire 03452
www.godine.com

Library of Congress Cataloging-in-Publication Data
Vaule, Rosamond Brown.
As we were : American photographic postcards, 1905-1930
Rosamond Brown Vaule.— 1st ed.
p. cm.
Includes bibliographical references.
ISBN 1-56792-250-3 (alk. paper)
1. United States—Social life and customs—1865-1918—Pictorial works.
2. United States—Social life and customs—1918-1945—Pictorial works.
3. Postcards—United States—History—20th century.
4. Photography—United States—History—20th century. I. Title.
E168.V385 2004 779'.997391—dc22
2004008813

As We Were was set in a digital version of Monotype Bell

Book design and typography by Dean Bornstein

First edition

Printed in China

CONTENTS

FOREWORD

———◆•••◆———

Richard Benson

By the year nineteen hundred photography had inserted itself into nearly all aspects of our culture. The early photographic processes, so akin to cooking in their home-made complexity, had disappeared under the on-slaught of the convenient dry plate, which was invented toward the end of the century. Photography filled printed books, sometimes in rich pho-togravure, but more often in the spare and washed out halftone prints made by letterpress. Billions of ink photographs spread their visual infor-mation throughout the world, and society's education and development was predicated upon their extraordinary power.

Photography was only about sixty years old when the century turned, and by that time it had become essential to many different trades. Journal-ists celebrated its power to document, and scientists its ability to record what no biological eye could see. Even though photography was not im-mediately accepted as art, the poor portrait painters quickly found them-selves shut out of the tremendously expanding market for likenesses. Wood and copper engravers gradually disappeared under the photome-chanical onslaught, and their visual and manual skills, like those of other artists, moved out of the economic mainstream of society. All these changes reflect photography's intrusion into nearly every area; like the computer today, this tool seeped into the fabric of our society, and changed what we were, and consequently have, become.

The versatility of photography stemmed in large part from its simplic-ity and economy; it required very little capital outlay by the practitioner. The astonishing record captured by the lens could be created by the skilled and dedicated professional or the rankest amateur. It is easy to overlook this source of photography's power—anyone can do it, and even at the most rudimentary level photographers can produce pictures that influence the world in ways that no visual images ever have before. While a formal painted portrait of a king or queen can be influential within the confines of the royal court, a simple halftone reproduction on newsprint,

printed in thousands of copies, has the power to instigate immediate and far reaching social change.

Much of photography's impact stems from its capacity to be printed in multiple copies. This can happen in the darkroom, where the photographer can produce a dozen prints of a picture in a few minutes, but it occurs with even more power when photographic imagery is linked to the printing press and its old ink based picture making systems. The press, however, requires time and expense to prepare its editioned output, and any picture, or page of text, rendered in ink requires complicated setup and oversight. The old pattern of carefully vetted editions that had, for so long, characterized bookmaking, attached itself early on to the reproduction of photographs. Editors and publishers—who are assuming the risk and paying for the product—control what appears in ink, and so the multiplicity that is powerful takes on the respectability and conservativeness that tends to occur when committees, rather than individuals, control the means of production.

In amongst the many forms of editioned, ink printed, pictures is the postcard. Tourists have always been one of the primary customers for photographs, and when postal regulations permitted stamped cards, with an address on one side and a picture on the other, these travelers immediately provided a market for huge numbers of these mementos. Publishers hired photographers, printers specialized in different printing methods, some in color, some in traditional black and white, and a vibrant industry was born. This industry was similar to the book trades; large publishing organizations dominated, and the vast majority of cards came from them, instead of the actual places that the tourists visited. This occurred because of the high cost and complex preparation necessary for the production of ink images.

Photography, however, had another life—that of the small edition printed chemically in the darkroom. Every town had its photographic studio, and every studio was equipped to make small runs of chemical prints to satisfy its customers. Aunt Edith, photographed for her ninetieth birthday, needed to be immortalized in at least two dozen prints, so every cousin (and potential heir and supplicant) would keep her firmly in mind. Each town with a studio also had its own special sights—quirks of the landscape or population—that might attract visitors or provide nostalgic reminders of times gone by. Many of these local wonders would never

make it in the big time of ink editioned postcards, so the local entre-
preneur stepped into the gap, and the real-photo postcard was born.

This book celebrates those cards, and their makers. The author focuses
on these little visual miracles produced in editions as small as one, or as
large as a few hundred. Ironically, these tiny, homegrown productions
used light sensitive silver as their basis, and so, despite their amateurish
aspects, their appearance usually far surpassed that of the formal, officially
produced cards. As we gather these bits of the past, dug out of shoeboxes
at antique fairs and flea markets, we find, scattered through the common
ink printed cards, pure gems of real photographic art. Original works, un-
fettered by responsibility to a cultural norm, but instead made by artists
of every stripe, lie waiting to be discovered, cherished and preserved.
What follows in these pages gives us a framework within which to place
these treasures of truly democratic art that might otherwise disappear
forever.

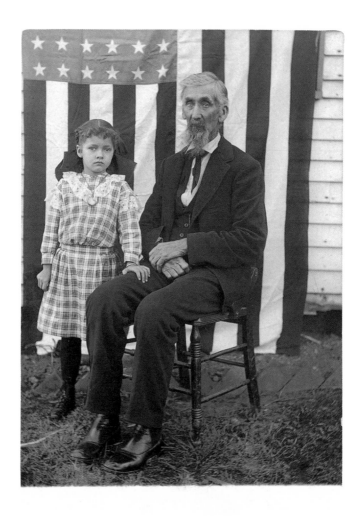

1910–1918.

¶ In 1915, the flag was a powerful presence in American life. War was raging in Europe and the War between the States had ended fifty years earlier. The old man, perhaps a Civil War veteran and the girl's grandfather, and the little girl are photographed with stars and stripes behind them. Her touch conveys affection and the physicality of her grip on his thigh brings us right into the reality of the picture. Youth and old age, war and peace, past and present, honor, patriotism, love—grand themes here.

ACKNOWLEDGEMENTS

Many people have supported this book in ways both direct and indirect, and some I wish to recognize here. Henry Deeks first called my attention to the extraordinary quality and subject range of "real photo" postcards, and many of my favorite cards have passed through his caring hands. Early on, Dick Soffey's Cape Cod shop offered hospitality as I got acquainted with old postcards while my son indulged his passion for baseball cards. To Greg French I am infinitely grateful for his patience and generosity in helping educate me about early photography of all kinds, particularly daguerreotypes. Rodger Kingston is a photographer, collector, and scholar who has been generous with his materials and knowledge. Credit is certainly due to Professors Judith Wechsler and Eric Rosenberg in the Department of Art History at Tufts University who not only cared deeply about photography but also helped lift my efforts to a more serious level. Eric served as my thesis advisor and I shall forever be indebted to him for his confidence that photographic postcards offered fertile ground for graduate research.

As to the book itself, Glenn Harriman and old friend/camera collector Sheldon Taft from Columbus, Ohio, helped flesh out my account of W. S. Harriman, a postcard maker working in central Ohio. Lois (Bisi) Mac-Murray Starkey generously shared family history and materials. Anne Havinga, Curator of Photography at the Museum of Fine Arts, Boston, offered encouragement as well as information and expertise throughout the preparation of this book. David A. Gibson, formerly with the George Eastman House in Rochester, New York, has been an invaluable resource, not only responding to my numerous inquiries related to Kodak products and camera technology, but also providing useful information and suggestions.

David Godine, my publisher, has been supportive and enthusiastic from the beginning, and put my text into the capable hands of editor Marlowe Bergendoff who helped hone my writing, and of designer Dean Bornstein who showed what a beautiful book this could be. Special thanks to Richard Benson, Dean of Yale's School of Art, who wrote the Foreword and whose knowledge and perspective enrich my subject.

Finally, I thank supportive friends and family: my own beloved Ohio family of generations past and present; and my husband, Sven, and children—Lars, Christina, and Nils—all of whom put up with my deadlines and obsessions, offered practical advice related to my computer and some of my less than productive interactions with it, and always provided encouragement and praise when needed.

My father, John Edwin Brown, Jr. 1912.

12

AUTHOR'S PREFACE

There I was, alone in the apartment where she had died, looking at these pictures of my mother, one by one, under the lamp, gradually moving back in time with her, looking for the truth of the face I had loved. And I found it.

Roland Barthes, *Camera Lucida*

AN OHIO FAMILY HISTORY

My grandfather, whose own life spanned more than a century, was born in 1864 in a small southeastern Ohio town. He always had baskets of travel postcards in his library that I remember looking through when I was a child. His upstairs study was filled with photo albums, family portraits, and yearly journals. Only many years after his death did I discover that some of the album photographs were, in fact, photographic postcards, called "real photo" by some American makers; and that a few of the hundreds of collected postcards were photo postcards of family, home, friends, and vacation spots. Most were never sent, but some had been mailed to my father when he was a little boy or to my grandparents by friends and family.

My own father, an only child born in 1903, died when I was a teenager. At a visceral level, these early photographs and photo postcards represent a personal quest for my own history, for my father, his childhood and youth. In writing this book, I share "the uneasiness of being a subject torn between two languages, one expressive, the other critical" described by Roland Barthes in his book of reflections on photography, *Camera Lucida*. After his mother's death, Barthes discovers the "Winter Garden" photograph that reveals the beloved mother he knew:

I studied the little girl and at last rediscovered my mother. The distinctness of her face, the naive attitude of her hands, the place she had docilely taken without either showing or hiding herself, and finally her expression, which distinguished her . . . all this constituted the figure of a sovereign *innocence* . . . all this had transformed the photographic pose into that untenable paradox which she had nonetheless maintained all her life: the

13

asserition of a gentleness. In this little girl's image I saw the kindness which had formed her being immediately and forever.[1]

A family photograph connects us with the past and, as Barthes reminds us, this connection can be poignant.

My grandfather's photographic postcards are a record of my father's childhood, all but one by unknown photographers. One shows my dad in rumpled play clothes at age five or six with a buddy—this a candid close-up. Another shows the cozy basement Colonial Revival "billiard room" of his first Columbus, Ohio, home with spinning wheel, bed warmer, and simply crafted furniture near the hearth and brass candlesticks on the fireplace mantle. The house was long ago absorbed within an institutional modern facade, but the candlesticks are in my New England living room. Other postcards present summer cottages at Indian River, Michigan, where nineteenth-century Columbus residents established a fishing camp that became a favored summer resort known as Columbus Beach. On one card, a best friend writes to thank my father for his recent "postal" and to encourage more. Another shows my father crouching to feed the pigeons in St. Mark's Square on a 1909 grand tour, a card surely made by a photographer kept busy by the tourist trade. I am reminded of my grandfather's story that an acquaintance he subsequently met in Vienna recognized himself in the background of that same Venice postcard—coincidental presence captured by the camera at a popular European travel destination. In another card my resplendent grandparents and their young son pose for a Florida resort photographer. A card comes to my grandfather "as a remembrance of your first assistant" who writes, "While reading the other day an amateur photographer happened in and asked permission to reproduce the likeness on the other side, a view of my ear, nose & throat room." And in May 1922, my grandmother is photographed on the White House lawn with her girlhood friend, Florence Harding from Marion, Ohio. My then teenage father would join them there, and my grandmother's enthusiastic notes about the visit refer to the ever present photographers, one of whom presumably took this postcard shot.

As records, these photo cards tell the story of a couple nurtured in nineteenth-century rural Ohio who moved into the Midwestern urban upper middle class and educational, professional, and social opportunities little dreamed of by their parents. Because these are family documents, I

14

Fanny Barker Brown and John Edwin Brown
with John Edwin, Jr. ca. 1910.

scrutinize the photographs, magnifying glass in hand: the porch of the Michigan cottage, the objects so carefully arranged at hearthside in the comfortable room on Broad Street, my father's quavering balloon, my grandmother's immense plumed hat, my grandfather's sturdy posture, my father's stance and serious expression. What was he thinking? What was he like then?

The cards tell only so much. The camera captures just *that* expression, just *that* shadow, *that* moment in time—a moment frozen forever in tones

of grey or sepia. What I see is neither complete nor conclusive. There is much, much more beyond the camera's framed view. For my grandparents, the card represented a souvenir of a place or a special occasion, a status proudly attained or an expression of delight in their son's young life. For me, the card becomes a way of getting closer to them as they were before I entered the continuum.

Far more than personal history, these postcards show a society in transition: from predominantly rural to urban, from agrarian-based livelihoods to the many occupations required to sustain urban and suburban life. And they convey the continuing American theme of land of opportunity and upward mobility. They represent a late-nineteenth-century marriage of two young people from adjacent Ohio farm towns. The bride's father ran the general store in McConnelsville. Across the Muskingum River in Malta, the Brown family produced plows. Both grandparents went to college, my grandfather the only one of his siblings to do so. "My inheritance," he said. He and my grandmother left rural Ohio to make a good life for themselves in the growing state capital, where he became a leading physician and mentor to other young doctors. They traveled. They idolized their son. They built a solid and spacious home in the expanding city. They went to the White House to visit an Ohio friend who had become president. Theirs was an American story, told in the postcards.

Like Barthes, I am moved by these images of family I have loved. I cherish them. But as he recognizes:

I cannot reproduce the Winter Garden Photograph. It exists only for me. For you, it would be nothing but an indifferent picture, one of the thousand manifestations of the "ordinary."[2]

How right he is. Others will not find these particular photographs so fascinating. They are, however, important for me and for my exploration of the material to follow. I read my Ohio photographs primarily for personal connection to my own past. My task now is to read and interpret the "real photo" postcards that follow on their own terms—as part of photographic history, as commercial products, as social and historical records, as conscious and unconscious expressions of early-twentieth-century life in the United States.

PART ONE

Definition and History

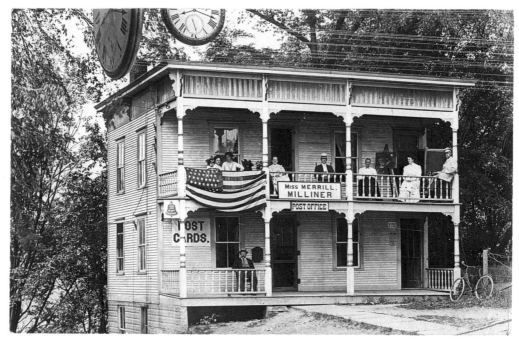

Photo by C. E. Runions, Star Lake, New York. 1910–1918. Courtesy of Henry Deeks.

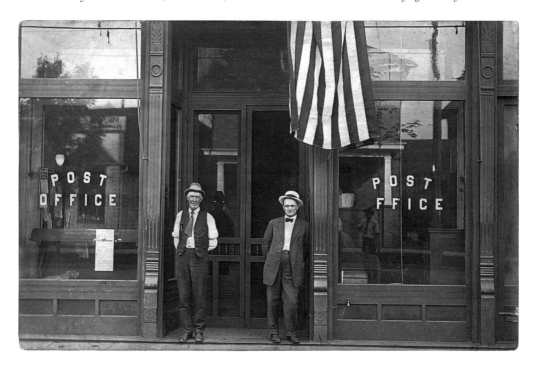

Post Office. Evansville, Indiana. 1910.

¶ Postcards, post offices, the flag, rural porches and urban storefronts—all reflect early-twentieth-century American life and the "real photo" era.

WHAT ARE THESE "REAL PHOTO" POSTCARDS?

AMONG the billions of postcards produced during the early twentieth century, a few million were photographic postcards that were original photographs made directly from film negatives or glass plates. Called "real photo" by some of their American makers, they are frequently known by that term today. While they were commercial products, they were also individual, eloquent works that reflected American life and values.

Photo cards are compelling because they are early examples of photography in mass culture, both in subject matter and usage, and because they occur at a remarkable time in American history. Their images present a broad spectrum of American life and occasionally reveal its darker side. It was Americans—urban, small-town, and rural—who bought, sent, or saved these postcards. They were made at a time of social, demographic, and technological change: when the nation was shifting from a rural to an urban society; when record numbers of immigrants were entering the country; when family members were leaving "home" to spread across the land; and when electricity, the telephone, radio, and automobile were entering mainstream culture.

More than any other twentieth-century photographic expression, these diverse and intimate yet public images blur the lines between professional and amateur photographers. Mostly anonymous, they were made inside the studio and out, by professionals in towns large and small, by itinerants, by amateur hobbyists—potentially by anyone with a camera. I hope the images I have selected will excite the reader's interest, please the eye, or illuminate a point. And although I have tried to ensure broad geographic representation, the locations of many of the cards illustrated are unknown.

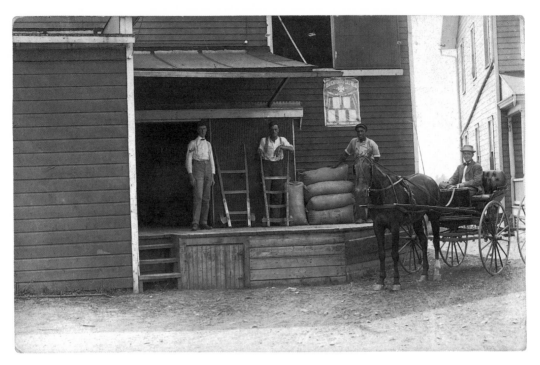

Loading dock. 1907–1910.

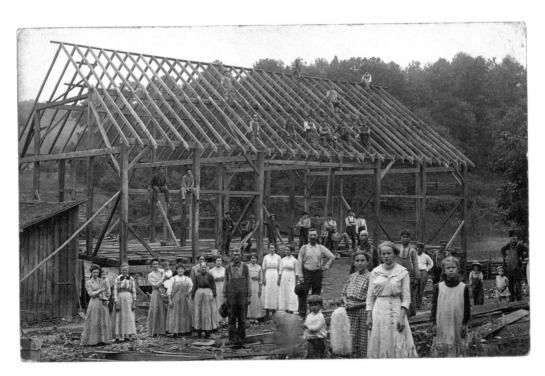

Barnraising. Wisconsin. 1907–1910.

¶ Neighbors of all ages turn out—to help raise the all-important barn, to socialize, and to pause for the photographer's record.

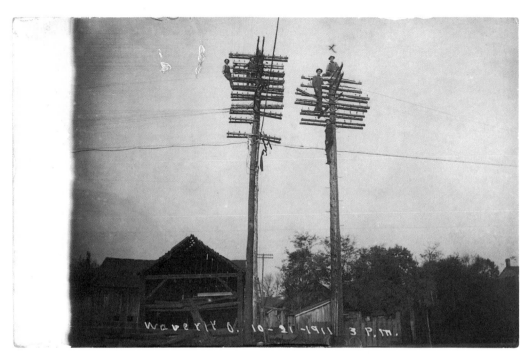

Waverly, Ohio. 1911.

"Good morn, Mrs. Green. This is us at Waverly, cleaning up after the big fire. Got a hurry call to go to Chillicothe. Goodbye. Dutch."

Postcards have long been a popular commodity, though never more so than during the first two decades of the twentieth century. Just as they were at the turn of that century, postcards—now, however, usually in glossy color—are found today in every city, resort, and tourist site. Travelers continue to be the mainstay of postcard consumption, buying and sending them with messages to friends and family back home or saving a selection for later review and sharing. Old postcards are now a major "collectible" and even in this Internet age, the very word conjures up quick, abbreviated connection with the past or with others.

Most popular from around 1905 into the 1920s, photographic postcards were but one small part of postcard production. The vast majority were produced by photomechanical means, reproductions of original photographs printed in ink from lithographic stone, metal, or glass plates, or by letterpress halftone. In contrast, "real photo" cards were actual photographs, products of chemical reaction caused by light on a light-sensitive surface. They were positive prints developed from glass plate or

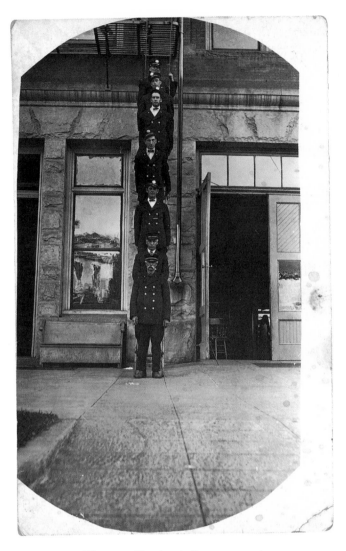

Firemen. Portland, Oregon. 1915.

"Dear Mother, I am all right and well, but am not happy, you know. Ron."

film negatives onto heavy, sensitized photo stock, cut to postcard size. Many images probably numbered a dozen or less, and some were even unique, whereas printed reproductions were produced in vast numbers. While mass-printed cards were in color or black and white, "real photo" images were always monochrome—black or brown in tone, often faded to sepia—with hand tinting occasionally added. As original photographs, some matte and some glossy in finish, they differ from printed reproductions in their continuous tone and lack of dot or grain pattern.[3]

Mechanically reproduced cards were primarily directed to tourists and travelers as they roved the nation and the world. Many Americans acquired and collected foreign postcards—including photographic ones—on their travels, but my focus is on American cards produced for the home market. In contrast to the stereotypes available for tourists in all kinds of postcards—"Mammy" from the rural South or a "little Apache" from the Southwest, for example—most "real photo" postcards derived from and catered to a different audience. Subjects were usually ordinary people and the buildings shown were apt to be ordinary stores or homes rather than well-known landmarks or public sites.

Photographic cards were developed by the photographer at home or in a studio, by a commercial photo supply house or studio, or even, in the early years, by the Eastman Kodak Company itself. The term "real photo" was one used by the makers, presumably to emphasize photographic authenticity and to distinguish their cards from the abundance of photomechanically reproduced and printed cards dominating the market.[4]

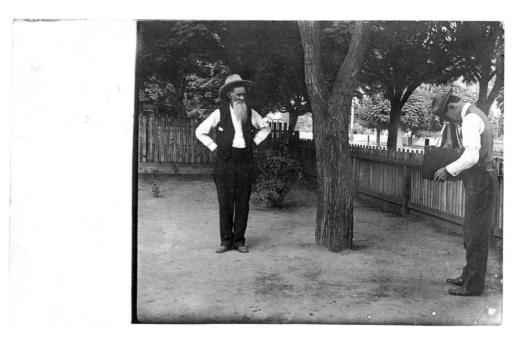

Photographer with reflex camera. California. 1910.

"I can't find time to write letters so have sent cards to my folks and to you. I am still making pictures. We made over $40 worth in July and are starting out pretty well for August."

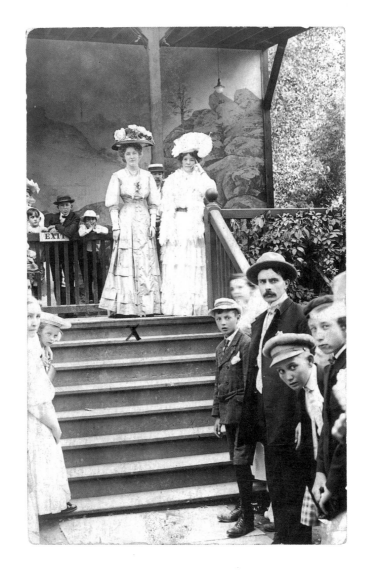

Denver, Colorado. 1907.

"This is a picture of Miss Margrete Fry, the National beauty of Denver."

¶ Even more than a picture of Miss Fry, this is a picture of a moment of antici-pation. Faces look expectantly toward the photographer and whoever or what-ever is coming, and toward us as well, so that we, too, share the moment.

THE PHOTOGRAPH

THESE cards were, after all, photographs, so let us consider just what that means. In the late twentieth century and in our new twenty-first-century world, the photograph is everywhere, so ubiquitous that we often fail really to see the image unless it shocks or connects with us in a personal way. Originally considered the mirror of reality and conveyer of truth, a photographic image today can be the ultimate deceiver—a digital fabrication created through modern technology. While today's audience brings legitimate skepticism to photo-related imagery, we are nonetheless inclined to trust its authenticity. Advertising firms, public relations advisors, and political spin-meisters recognize and exploit that trust. Contemporary artists frequently play the edge between viewers' expectations of photographic truth and their recognition of deception or fantasy.

How do we define the power of a photograph made nearly a century ago? As with any photograph, its power is dependent upon time and place and the relationship established between maker, subject, and viewer. The photograph is inherently historical, offering up a moment from the past on film or paper that serves as evidence of its existence. The viewer assumes that whatever was captured in the image actually existed, but knows that its particular moment was gone the instant it was captured on film. What is recorded and how it is shown depend on the photographer's discretion, the subject itself, and the context; and the image may reveal both unconscious and conscious intent. The encounter between the "now" of the forever vanished past, experienced by the subject and witnessed by the photographer, and of the viewer's contemporary sensibilities gives photography its peculiar power and resonance—a reminder of the passage of time and of our own mortality.

Various photo historians and critics have explored photography's unique nature. In the 1930s Walter Benjamin described the "aura" of very

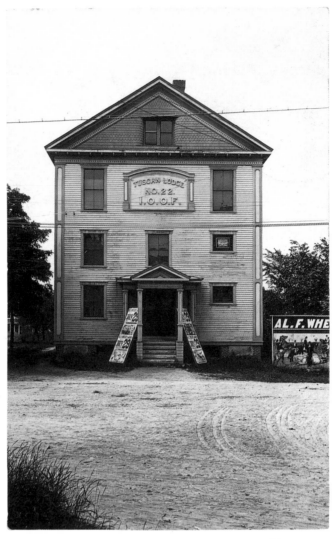

Tuscan Lodge. Dixfield, Maine. Photo by Lee L. Abbott. 1909.

"I will send you some views of the place so you can see
how we look up here. . ."

early photographs, which he believed retained the authenticity and authority essential to a work of art. But as portrait photography became established, Benjamin saw aura give way to "artistry" and convention. For Benjamin, the French photographer Eugène Atget represented the beginning of something new. Devoid of people and formal portraiture, Atget's views of Paris in the early 1900s relinquish the trappings of con-

26

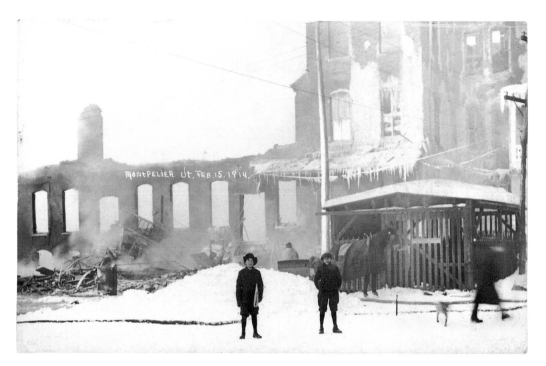

Montpelier, Vermont. February 15, 1914.

¶ Still smoldering brick ruins, ice, and snow make a dramatic backdrop for the two boys who anchor the image and confront the viewer. Dog and pedestrian are barely legible as they rush by in the cold.

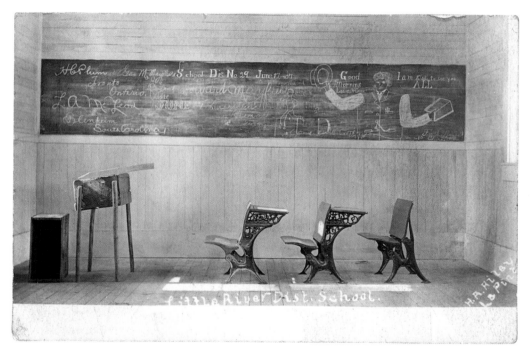

Little River District School. Photo by H. A. Riley, La Pine, South Carolina. 1907.

¶ A tiny schoolroom is animated by light, blackboard words and drawings.

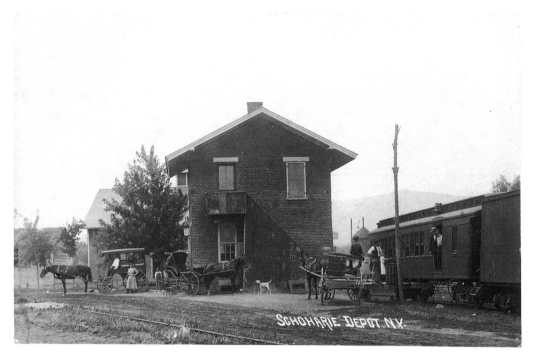

Depot. Schoharie, New York. 1910.

"See if you know any one or two in the picture. Mason Haines and
John stand in the car door there."

¶ A lively depot scene of turn-of-the-century small-town life becomes personal
and time-specific through the written message.

ventional photography and simply present the image as document or evidence.[5] In the best of "real photos," not only do we respond to the presence of an original photographic print, but we are also confronted with an apparent straightforward image from the past that carries the authority of evidence.

One of photography's early enthusiasts, Oliver Wendell Holmes, noted that in contrast to painting, everything the photographer frames in the image is retained for the viewer to discover, often even more than the photographer saw or than the subject knew was there.[6] As a transparent medium, the photograph has no surface in which to get involved—just the image itself. The image reveals its details to careful viewing, a crucial piece of photographic and "real photo" appeal.

Whalen, Kentucky. 1909.

"Em, here is our picture taken in front of the store."

On the subject of photographs from an earlier era, critic Susan Sontag raises a key issue:

> A photograph of 1900 that was affecting then because of its subject would, today, be more likely to move us because it was a photograph taken in 1900. The particular qualities and intentions of photographs tend to be swallowed up in the generalized pathos of time past.[7]

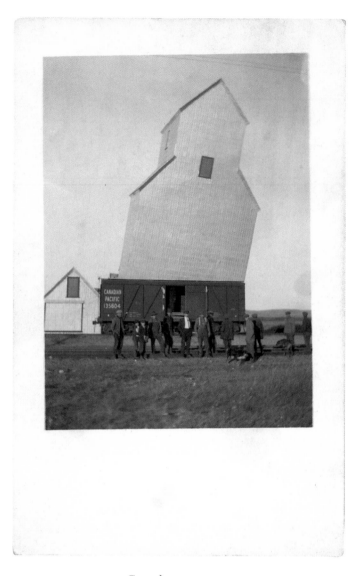

Canada. 1910–1918.

¶ Careful framing of this tilting grain elevator offers humorous commentary on a serious structural problem.

Although there are exceptions, Sontag's "generalized pathos of time past" affects many photographic postcards. Often called "remembrance," these are photographs linked to our memory. We become sentimental about them. They remind us of times gone by, of our own mortality, and they evoke a nostalgia that family photographs inevitably push us to in-

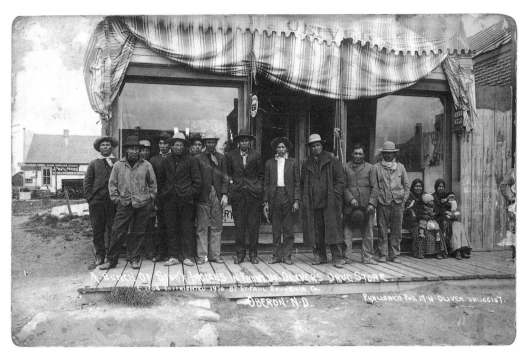

Sioux Indians in front of Oliver's Drug Store. Oberon, North Dakota. St. Paul Souvenir Co., published for M. N. Oliver, Druggist. 1910.

"I arrived here OK. We are going to work Monday."

¶ In the distance, a John Deere sign links North Dakota's past to the present.

dulge. Old photographs do become special and valuable to us—as documents, records, souvenirs, memento mori—treasures from the past.

Some photographs, however, defy such transformation through the sheer power of their subject matter, as in images of violence. *Without Sanctuary*, a collection of lynching photographs and related essays, shows us some horrendous images that were part of "real photo" production, and quotes a contemporary account of postcards made at a Tennessee lynching in 1915:

Hundreds of kodaks clicked all morning at the scene of the lynching. People in automobiles and carriages came from miles around to view the corpse dangling from the end of a rope. . . . Picture card photographers had installed a portable printing plant at the bridge and reaped a harvest in selling postcards showing a photograph of the lynched Negro.[8]

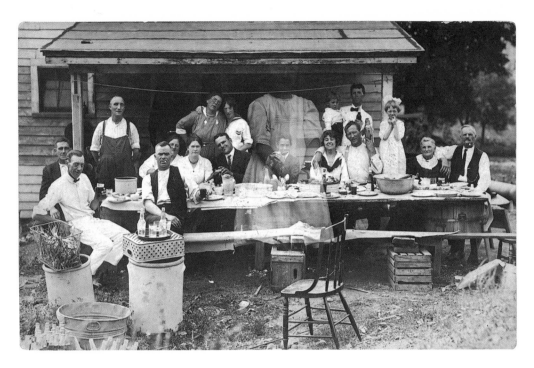

1918–1920s.

¶ "Spirit" photography began as a nineteenth-century phenomenon in which a faint image, or "ghost," said to be a spiritual presence, was captured during an otherwise normal exposure. Whether deemed fraudulent or credible, such images even today inspire debate. Perhaps this careful double exposure with an empty chair in the foreground was intended to portray a spirit in the midst of family celebration. Whose spirit was called forth and why? Or was this the photographer's otherworldly accident?

Despite the current trend elevating nearly any early photograph to special, even artistic status, quality varies. Some successful photographs offer clues or engage us. Some suggest constructed image or metaphor. Some reveal a moment of beauty or disequilibrium. The photographer—including the postcard photographer—makes choices, and can sometimes produce compelling or poetic results. Occasionally, one encounters a powerful, moving, or surreal postcard image—a small, photographic work of art.

Some claim that photography was rather quickly appropriated as a means of economic and social control. We see this today in applications ranging from criminal mugshots and photo IDs to surveillance and advertising promotion. Certainly photographic postcards were part of social and economic history. Embedded in the transition from rural to urban America

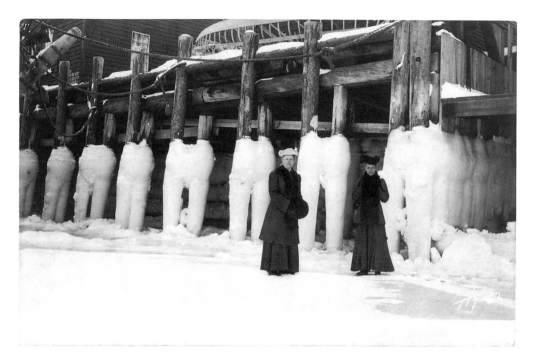

1905–1906.

¶ Frozen pier pilings whose icy cover reflects a previous high watermark stand like giant white trousers behind these sober dark-clad ladies.

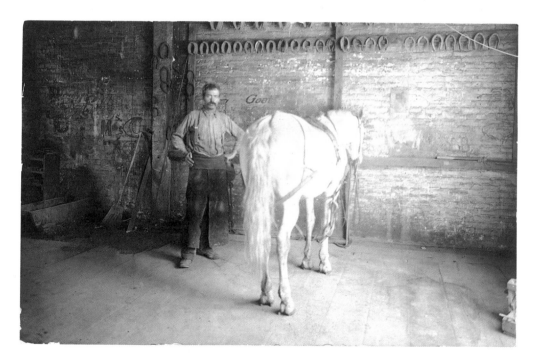

1907–1912.

¶ "Goat" and other graffiti are visible on the wall behind this blacksmith who poses for the photographer beside the luminous white horse he's shoeing.

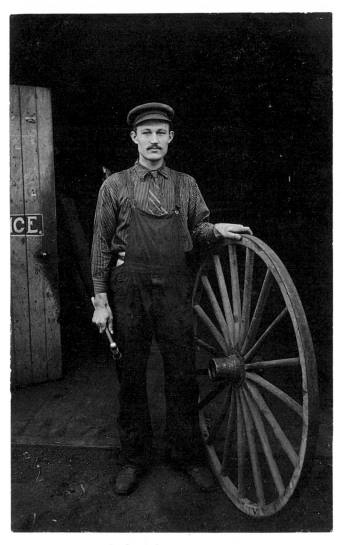

Wheelwright. 1909–1912.

and the introduction of new technologies into mass culture, they were commodities relentlessly promoted by one of America's great entrepreneurs and global capitalists, George Eastman, who saw the broad role the camera could play and aspired to make every person a photographer.

Think of the language of photography. A photo is shot. The camera is acquisitive. It catches a moment; it captures an image; it takes a picture. And photographs are consumed voraciously, visual substitutes offering pleasures sometimes preferred to actual experience.

Thus, the photograph can be said to exercise power in both its making

and its viewing: the object captured as an image by someone for some purpose, and the viewer, whether then or now, bringing his or her own perspective and appetite to the act of looking. The "real photo" postcard, revealing a real person or place or event caught by the camera in an earlier time, shares this power. It connects the contemporary viewer with an era shaped primarily by the nineteenth century and the earliest years of the twentieth century, before "modern" America burst forth and before the digital age liberated the photographic image from an actual moment or place in time. Through its everyday subject matter, small scale, and especially its sender's written message, the photographic card achieves a persuasive relationship and intimacy with its later witness. Bombarded with media imagery, today's viewer struggles to believe in the integrity of what the camera provides and finds in the "real photo" a worthy recipient of both trust and attention.

Ohio. 1911.

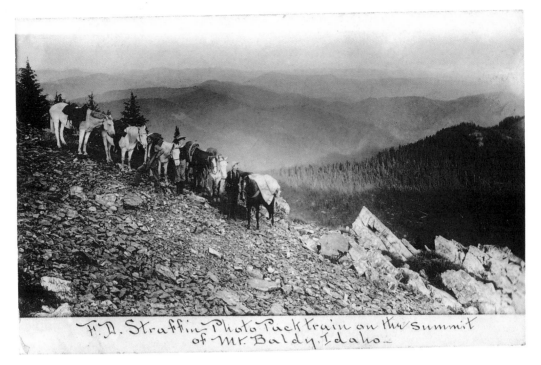

Photo pack train. Mount Baldy, Idaho. 1908–1911.

¶ This image recalls earlier survey photographers who transported heavy, cumbersome equipment to record the natural wonders of the American West.

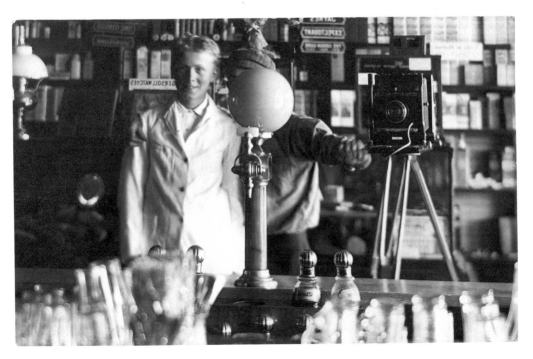

1910–1918.

¶ Two young photographers try a reflected self-portrait in the soda fountain mirror, using an old-fashioned folding view camera.

⌈ CHAPTER THREE ⌉

HISTORICAL CONTEXT

THE EVOLUTION OF EARLY PHOTOGRAPHY

Early photography was complicated. A would-be photographer needed not only extensive and expensive materials and equipment but also sufficient knowledge of optics and chemistry to put them to use. Time-sensitive laboratory work was necessary, since wet plates had to be coated, exposed, and developed before they dried. Lengthy exposure times were required to register an image; moving objects literally disappeared, though sometimes a residual "ghost" was caught by the camera. By 1880, factory-made dry plates, which could be developed hours, days, or weeks after their exposure, replaced wet ones. Exposure times decreased and in 1889, celluloid "roll" film was introduced. The camera, smaller, lighter, and now portable was simplified and made affordable. No longer the exclusive domain of a knowledgeable elite, photography would soon belong to the amateur as well.

During photography's early years, some feared the incursion of this new technology into art. Charles Baudelaire lamented the trend in painting toward realism and "truthful" representation, preferring his own definition of art, which called for an imaginative search for beauty. At a time when most people were awestruck by the daguerreotype's ability to mirror nature and admired paintings of high detail and finish, Baudelaire disparaged the camera. He considered it a soulless tool, useful only for record keeping, a "humble handmaid" of the arts and sciences.[9] A familiar debate that would challenge later artist-photographers began: was photography art or a blunt recording tool? In fact, painting in the second half of the nineteenth century was already moving away from illusionism toward subjectivity, toward a growing preoccupation with its own medium and picture plane. And clearly, photography, if not acknowledged as art, was *an* art, requiring specialized knowledge and care. Science, or perhaps

intellectual curiosity rather than artistic expression, may have been its initial impetus, but with master daguerreotypists like Nadar in France or Southworth and Hawes in the United States, it quickly went well beyond the bounds of scientific application.

In photography's infancy, all practitioners had to meet its considerable technical challenges. Sometimes they shared a curiosity about optics, an appreciation of natural beauty, or a quest for adventure. Some were driven by an entrepreneurial zeal that led them to experiment, to photograph exotic places, to satisfy public curiosity and the demand for portraits or pictures of popular sites.

Their product defined them, because only the skilled photographer was capable of producing a photographic image. As photography's popularity grew, some professionals voiced concerns about the decline of knowledge and training among the many newcomers entering the profession. Thousands of photo studios in American and European cities produced first daguerreotypes, ambrotypes, then mounted photographs, *cartes de visite*, cabinet cards, stereographs, tintypes, and formal paper portraits. Operations ranged from large-scale to one-person enterprises, with production as diverse as portraits, landscape vistas, exotic locales, and photographic records for institutions and government agencies.

Among these early photographers were gifted and ambitious practitioners who appreciated and understood the technology, the nuances, the expressive qualities of the medium and brought passion to their work. With the remarkable technological tool of the camera, they could create images worthy of display. They could make art. A camera in the hands of nineteenth-century photographers such as Nadar, Julia Margaret Cameron, or Timothy O'Sullivan became a means of profound expression. A critic wrote of Nadar's portraits in 1859: "They demonstrate that an intelligent man uses his brains as well as his camera, and that if photography is by no means a complete art, the photographer always has the right to be an artist."[10]

If photographers could be artists, were they coming from the amateur or professional ranks? Both were exhibiting their work. Alfred Stieglitz recognized that whether or not a "professional" livelihood was involved, art derived from passion and devotion. He wrote in 1899:

Let me here call attention to one of the most universally popular mistakes that has to do with photography—that of classing supposedly excellent work as professional, and using the term amateur to convey the idea of immature productions and to excuse atrociously poor photographs. As a matter of fact nearly all the greatest work is being, and has always been done, by those who are following photography for the love of it, and not merely for financial reasons. As the name implies, an amateur is one who works for love.[11]

In an effort to broaden the reach of photography, the Eastman Kodak Company sponsored annual photography competitions with cash prizes. By 1905 the company had organized the competition into a number of "open" and "novice" classes. In the former, "experienced and successful workers compete," and in the latter, "the less experienced vie with each other for prizes and honors." Among the top Class A Open award winners that year were: Edward Steichen, New York City, first prize winner ($150), and Alfred Stieglitz, New York City, whose "Kodaking" won the $50 third prize. As New Yorkers of some renown, Steichen and Stieglitz were in the minority. Serious interest in photography extended across the nation and beyond its borders. Other award winners whose names remain unknown hailed from Kentucky, Pennsylvania, Oregon, Indiana, California, Maryland, and Ohio, and from England and Scotland.[12]

The early years of the twentieth century, the era of the "real photo" postcard, were filled with extraordinary artistic and intellectual ferment. The year 1907, for example, saw the production in Europe of both Picasso's radical *Demoiselles d'Avignon* and the expressive colorist *Joie de Vivre* by Henri Matisse. Surrealism and Dada were nascent. In this country, Frank Lloyd Wright was approaching architecture in a new way in his earth-hugging, rectilinear prairie houses, and realist painters were turning to gritty urban life for subject matter. While these expressions were not directly reflected in popular photography of the time, there was a link with serious American photography. Alfred Stieglitz, by then America's most highly regarded photographer, personified that link: his Little Gallery (later known as "291") in New York City was the first to show new "modern" art in the United States. Stieglitz, who only two years before had won third prize in the Kodak Open competition, photographed and published *Steerage* in 1907, the same year that Picasso and Matisse painted their masterworks. It was Stieglitz's photograph of Duchamp's

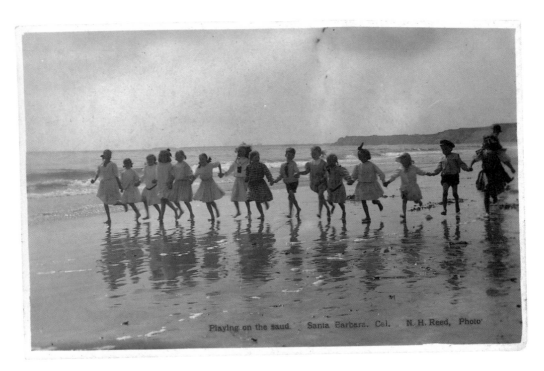

Playing on the sand. Santa Barbara, California. N. H. Reed, Photo. 1910–1912.

¶ This is a rare example of a pictorialist "real-photo" card.

"ready-made" urinal *Fountain* that brought this radical art object to public attention. Ironically, the same photographer who had been recognized by George Eastman's growing commercial empire of popular photography now epitomized the American artistic avant-garde.

Pictorialist photographers like the early Stieglitz and Clarence White didn't just aim and shoot. They sought out their subject and moment patiently, manipulated the printing process, and even reworked the negative for specific effect. They believed the photograph could be a work of art equivalent to painting or any other unique artistic creation. Occasionally, soft-focus photographs in the pictorialist mode found their way onto postcards. In Boston, the Union Camera Club and Maynards published "artistic" postcard images of urban landmarks in photogravure.

Postcards were made by other known photographers, including Edward S. Curtis and L. A. Huffman who sought in different ways to preserve the vanishing West through their photographs. In the early 1900s, Curtis made postcard reproductions in halftone of some of his

Native American images. From his studio in Milestown, Montana, Huff-man produced the Huffman Pictures, a series of photogravure postcards reproduced from glass-plate images of a wilder West in earlier decades.[13]

Working in New York City around the turn of the century but far re-moved from Stieglitz and the modern photographs and paintings exhib-ited in his Gallery 291, were photographers whose work documented urban poverty and the need for social reform. Jacob Riis showed late-nine-teenth-century immigrant life in its stark reality. Lewis Hine's moving portraits of child labor pushed for social change. Their work had formal beauty and emotional power derived from their subject matter, the feel-ings they held for it, and the skill with which they used the camera.

Clearly, the camera now had various roles: art, record, remembrance, and tool for social change. George Eastman's innovations expanded those roles, as we shall see.

GEORGE EASTMAN'S VISION

Although photography began in Europe, it was an immediate success in the United States. During the nineteenth century, Americans flocked to photo studios for the inexpensive portraits that photography provided. But the camera remained in specialized and professional hands. By the turn of the century, George Eastman, who understood its democratic po-tential, had turned the camera into a popular tool and photography into a mass medium.

Originally a producer of photographic glass plates, Eastman founded the Eastman Dry Plate Company, later to become Eastman Kodak Com-pany, in Rochester, New York, in 1880. Determined to make photography a truly popular medium, he simplified camera use and made it affordable. Applying his marketing brilliance to cameras and photographic products, he invented the name "Kodak" for his products, a word he believed would be catchy and easy for customers to remember, whatever their language. In 1888 he introduced his "Kodak" box camera with paper-based stripping roll film for one hundred exposures, a major change from heavy, cumber-some glass plates. In the early days, because of the difficulty of handling delicate roll film, the user sent the whole camera back to Kodak where it was unloaded and its film developed; the reloaded camera and its mounted photo prints were then sent back to the customer. The Kodak slogan was

41

Photo outing. 1910.

¶ Kodak's 2A Folding Pocket Brownie is shown on a tripod.

"You Press the Button— We Do the Rest." The introduction of flexible celluloid roll film in 1889 facilitated handling, but it was Kodak's "light-proof" cartridges first marketed in 1891 that especially appealed to the inexperienced photographer who was now able to load or remove film anywhere. Now the handheld camera was truly in amateur hands, liberated from both tripod and darkroom.

Glass plates continued to be an option and, thanks to adapters, they could even be used in some later camera models designed for celluloid film. It was not until World War I that Kodak began phasing out the manufacture of glass plates.[14]

Throughout the 1890s, Eastman and others produced various camera models and products for an expanding market that would include amateurs and professionals of all ages. In 1900, Eastman introduced a one-dollar camera, made of sturdy cardboard, which he named for Palmer Cox's "Brownie" cartoon character, piggybacking on the trademarked "Brownie's" popularity and implying that with the Brownie, even a child could operate and afford a camera.[15]

Lady with Brownie. 1909–1912.

¶ Tourism and the camera: a continuing partnership.

George Eastman's vision for Kodak was that it play a central role in everyday life. He had strong ideas about marketing and understood the power of nostalgia, as these words from a 1906 catalogue show:

THE HOME SIDE
An old, old friend drops in for the evening.

Talk turns to other days and presently the ancient family album and the basket of loose photographs appear from nowhere. Full they are of pleas-

43

ant memories and in reminiscent mood each of you recalls a tale of the past that through all the years has remained as clear within the mind as a happening of yesterday. And, though you do not admit it to anyone—hardly even to yourself—there is one picture that makes your heart beat just a trifle quicker, and for the moment you forget the chatter of the friends present, in a dream of a friend of the days long ago.

And then you go to the drawer in the old secretaire and fetch out a little package of Daguerreotypes. Quaint they are, with their ornamental cases and red plush and gilt. And as you look at the picture of grandfather on his fifteenth birthday, you declare that "John looks just as his great grandfather did."

To you those pictures are beyond price. But what a delight if they were only supplemented by something less formal—Kodaks of those childhood days, Kodaks of the days of young man and womanhood, Kodaks of the things that they were interested in, and then Kodaks of their sunset days.

But the Kodak had not come then. Photography was but creeping. It was the mysterious dark art, not the intimate part of home life that it is today. Photography has worked wonders along the road of scientific research; but of what value is the photograph showing the flight of a comet compared with the Kodak of baby taking his first steps? The photographic record of a seismic disturbance may appeal to a few dry scientists, but it is insignificant in interest when alongside the Kodak of *the* four-year old, proud in the possession of his first trousers with pockets.

Strongly as photography appeals in every phase of living interest, in science, history, travel, sport, 'tis in its home side that it touches most vitally. Therein is the true witchery of Kodakery.[16]

Eastman wanted to demystify the "dark art" of photography, to bring it into the home. He fully understood the personal pull of the old photograph. Modern photography's "witchery" was intended to capture "the home side's" informality for future sentiment and nostalgia.

In many ways, Eastman Kodak was the quintessential American manufacturing firm, premised on the certainty of an ever expanding market and the challenge of selling products of universal appeal to the greatest number of people. George Eastman's formula, which worked so well in the United States, was also applied abroad. When Eastman Photographic Materials, Ltd., built a factory in England in 1890–1891 to serve foreign markets, Eastman Kodak became an international presence.[17]

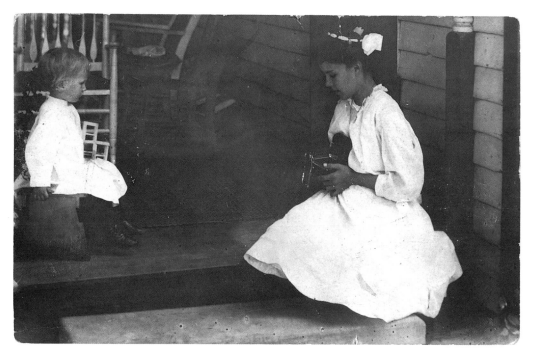

Girl using handheld camera. No. 1A Folding Pocket Kodak. 1907–1908.

¶ This is the usage George Eastman sought: a Kodak of "those childhood days."

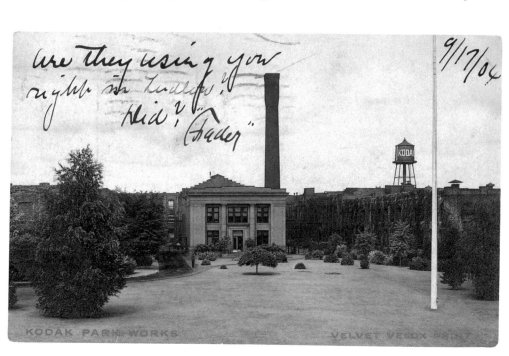

Kodak Park Works. Souvenir, Eastman Kodak Co. Rochester, New York. 1904.

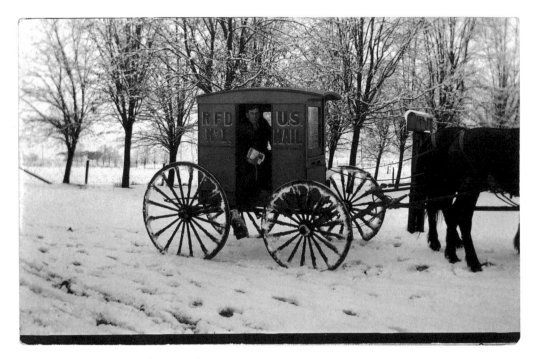

Rural Free Delivery wagon, RFD No. 1. 1910–1917.

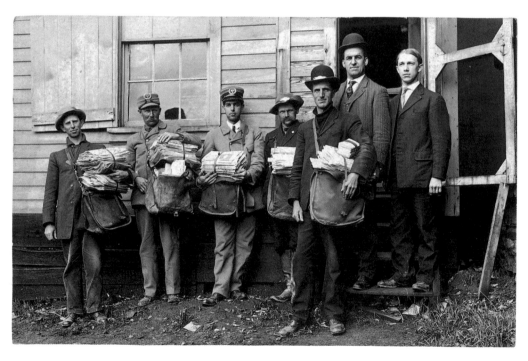

Postmen. Ohio. 1907–1912.

THE PICTURE POSTCARD

BOTH the popularity of postcards and regulations regarding their use developed throughout the world during the last decades of the nineteenth century. In 1869, Austria authorized the first government-issued post-cards. By 1873, the U.S. Postal Service began to issue cards with imprinted postage stamps and space on the reverse side for a written message. There were initial concerns about this new kind of public correspondence: loss of privacy, potential for public libel or insult to the recipient, and the degradation of written communication that such brevity imposed. But the postcard was here to stay. In 1878, the World Congress of Universal Postal Unions set standard postal card dimensions, and in 1886 it sanctioned international circulation. The Paris Exposition of 1889 introduced not only the Eiffel Tower but also the souvenir picture postcard. The 1893 Chicago Exposition inspired the first widespread use of privately printed picture postcards in the United States. In 1898, again following Europe's lead, the "Private Mailing Card Act" equalized mailing rates at a penny

Private mailing card.
Franz Huld Publisher, New York. ca. 1900.

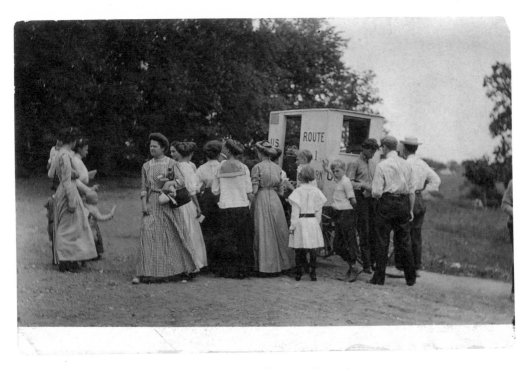

Mail delivery. Elkhorn, Wisconsin.
"A real photo by H. Montgomery, Hartford, Wisconsin." 1909.

each for privately printed and U.S. government-issued cards. And by 1901, private cards had their own identity as "post cards" in contrast to government-issued "postals."[18]

Rural Free Delivery was established in 1898, and within a few years offered home mail delivery to population centers of fewer than ten thousand. At a time when the telephone was not yet an integral part of the American household, postcards provided both a visual and written link, whether from across town or across the nation. Delivery service was rapid and frequent, as often as three or more times a day.[19] Postmarks attest that a card or letter sent within a given city or between nearby towns could be mailed in the morning and received the same afternoon. These innovations and extensions of postal service in combination with George Eastman's widely accessible and inexpensive photographic products set the stage for the photographic postcard boom that would follow.

The popularity of postal cards both inspired and was encouraged by images on one side of the card. Advertisers were the first to recognize the potential of pictorial cards, placing small ads on the message side as early

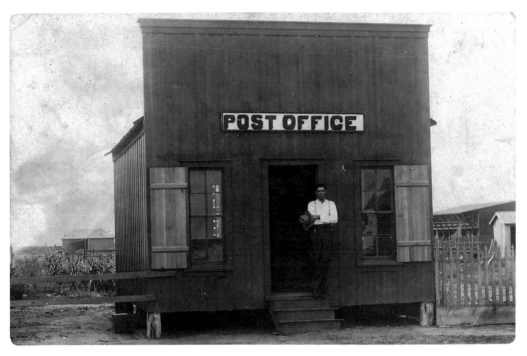

Woodsboro, Texas. 1910–1918.

as 1878.[20] Improved mass printing techniques strengthened the trend. Collecting picture postcards became fashionable and was further popularized by clubs and competition. In 1900, the British firm, Raphael Tuck & Sons, a premier publisher of colorful illustrated postcards, offered cash prizes to Tuck postcard collectors.[21]

Initially, government regulations caused a conflict between image and handwritten text. Only the address was permitted on the stamp side, so the message coexisted or competed with the image. First in Britain in 1902, and eventually in the United States by 1907, the "divided back" offered a practical solution: image on one side and message and address on the other.[22] Postcard production, already strong in European countries, exploded with this measure, and postcards became a booming business for artists, photographers, and printers on both sides of the Atlantic.

Postcard publishers large and small fed the market in the United States, and until World War I, the majority sent their photographs to Germany for printing, often by collotype—reproductions made from glass printing plates—or by photolithography or letterpress halftone. Such firms were

responsible for the masses of printed postcards in color and black and white showing cities, scenic views, historic sites, natural wonders, and tourist attractions of all kinds.[23]

There were many reasons for the postcard's remarkable popularity. New postal regulations, innovations in mass printing processes, tourism and curiosity about distant places, convenience, a desire for inexpensive communications, marketing and promotion, status, and fashion all helped promote the sending and collecting of postcards. And at a time when many adults had limited schooling, the postcard's written brevity doubtless held appeal. But the popular psyche may have been involved in other conscious and unconscious ways: dreams and fantasies could be indulged through inexpensive postcard images of all kinds. Many cards carried printed messages—romantic, humorous, titillating—or seasonal greetings accompanied by appealing and colorful drawings. Some were intended to feed a popular cause, to propagandize. And all were public: the image selected and message written were there for the world to see. The sender became a "public author." Exhibitionism, voyeurism, vicarious pleasure, a sense of superiority, even laziness deserve some credit for this mass phenomenon.[24]

In 1903, the *Kodak Trade Circular* declared: "The postal card craze has struck this country. It was a little slow in crossing the Atlantic, but it's here."[25] The April 1907 *Trade Circular* reports this change and its projected impact upon photo postcard production, a business that "has been growing tremendously during the past two years. Now that the back may be reserved entirely for photographic printing and a considerable message still written on the face, the photographic post card will surely become even more popular than heretofore."[26]

A message on a "real photo" Indiana card of 1910 demonstrates the postcard's grassroots popularity:

Dear Aunt and Family,
I had a post card shower on Joe Monday. He got 42 cards. Didn't mean to slight you folks, but you can send yet if you like. He got 3 today so it won't make any difference. Emma McM.

By this time, it seemed as if every American home had a postcard album on the parlor table. The album's role went beyond domestic entertain-

1910.

ment and the preservation of precious souvenirs and family history. It also conveyed social standing and sophistication, depending on the quality and origins of its postcard contents. The album itself has its own history. Initiated by Queen Victoria to protect and display her own collection of *cartes de visite*, albums became the rage and were adapted for all kinds of visual materials, including cabinet cards, tintypes, mounted photographs, postcards, snapshots, film negatives, and other nonphotographic ephemera.[27] Their contents reflected the range and evolution of the photographic medium as well as recreational, travel, and collecting interests. Into the postcard albums went a variety of postcards: some received, some pur-

chased and retained as souvenirs, some seasonal, some humorous, some colored, some not, some artist-signed, some "real photo."

The numbers of postcards in circulation were staggering: millions of cards sent within European countries and the United States; billions printed annually by German lithographers alone. In 1905, seven billion postcards were sent worldwide.[28] The official U.S. figure for postcards mailed in the year between July 1, 1907, and June 30, 1908, was 667,777,798—more than seven cards for every American. By 1913, the annual total had risen to around 968,000,000.[29] Most abundant were photomechanical reproductions based on hand-tinted black and white photographs showing cities and tourist attractions in the United States and Europe. A very few were themselves original photographic prints, developed from glass plates or film negatives directly onto photo postcard stock, and it is to the American "real photo" that we now turn.

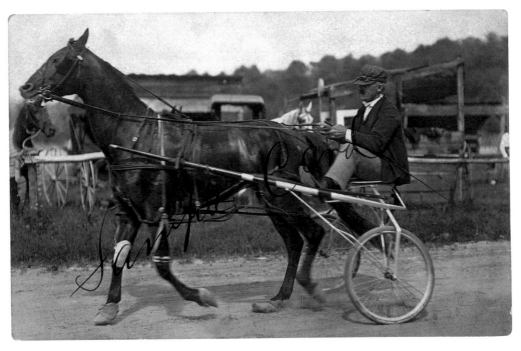

Sample card. Photo by Fay McFadden. Granville, New York. ca. 1911.

¶ Stamped on the back of this card are the words, "Photographed with a Press Grafflex." Introduced in 1901–1902 and produced until 1960, the high-speed, portable Graflex camera had a reflex focusing system with viewer that showed the image upright and full negative size. It proved a boon to journalists and to outdoor action photography. A handwritten note on the card further states, "20 cards for $1.00."

EASTMAN KODAK AND "REAL PHOTO" PRODUCTION

THE Eastman Kodak Company anticipated, met, and built the market for photographic postcards. From as early as 1902, its trade circulars and catalogues include numerous references to postcard-related products for both amateurs and professionals. Capitalizing on the popularity of travel and its natural partnership with souvenir photography and postcard communication, Kodak introduced photo stock specifically for postcards in 1902, and from 1903 until 1941, produced various models of the 3A camera that used postcard size film.[30]

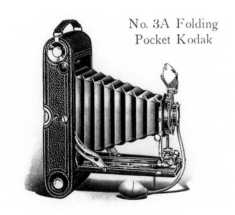

No. 3A Folding Pocket Kodak

Catalogue advertisement. 1911.

¶ This ad shows the 3A Folding Pocket Kodak, priced at $20, which takes 3¼" x 5½" postcard-size pictures and is commended for "its applicability to post-card photography, but also for the unusually effective landscape views that it yields horizontally and the beautifully proportioned full length portraits, vertically."[31] Other models of this popular 3A camera included the folding Brownie (1909), the Autographic (1916), and many others.[32]

The Kodak's 1903 catalogue carries a large announcement promoting the new Velox postcard paper stock aimed at the expanding amateur market of middle- and upper-class Americans:

VELOX POSTAL CARDS

may be sent through the mails by affixing stamp on the address side. Sensitized on the back and have a surface suitable for writing upon. They make delightful souvenirs for travelers to send to their friends. Owing to the ease of manipulation, one may readily print on Velox postal cards in the evening at one's hotel, and the following morning they may be written upon and mailed. They are especially advantageous in this respect to the touring amateur who has taken along his Kodak and Developing Machine.[33]

By 1903, Kodak did indeed offer a developing machine, which it described as an improved method of developing film to the "old way, in the dark-room."[34] Another machine for amateur use was the R.O.C. Postcard printer, "made for the man who desires an inexpensive, yet rapid and trustworthy machine for printing developing-out post cards" and intended for use at home or in the studio.[35]

In a 1904 article titled "Velox Postals for Vacation," Kodak states:

The dealer who stocks Velox postal cards in quantity will hit it right this year. The Post Card "craze," which started in Europe, is sweeping over the western hemisphere and printing on postals from one's own negatives is indeed a very interesting diversion.

Everyone who goes away on a trip with a Camera has promised to send back pictures; the Kodaker at mountain inn or seaside hotel has taken pictures of new acquaintances and has agreed to send them prints. The photographic postal card affords a convenient and unique way of fulfilling such promises.

Display some Velox postals with attractive pictures on your counter. You will find there will be a big business in them.[36]

From 1906 to 1910, Kodak further capitalized on the postcard craze by offering factory processing and printing of amateur negatives at ten cents a card.[37]

Another promotion was the use of blueprint paper stock, and later a similar sepia stock, for amateur cyanotype postcard prints that remained

Prison Chair

Rockland, Me
October 24, 1906

Dear Grace:—
We expect to
leave here tomorrow
morning if nothing
prevents.

Will.

Cyanotype. Maine. 1906.

popular until the 1920s.[38] Unlike the other "developing out" papers that required darkroom developing with chemical solutions, this blue "printing out" paper could be used by anyone. Printed in daylight, it only required washing in water after printing to remove the unexposed salts.[39]

Producers other than Kodak were involved in the postcard market. Several produced postcard paper stock. Except for cyanotypes, photo papers were chemically treated with gelatin silver emulsion on one side to receive the image. The back of the card was imprinted with the standard postcard format, heading, and stamp box that often carried the manufacturer's logo. Details varied slightly according to year and manufacturer and can be "read" for that information. The most frequently used papers and their manufacturers were Velox and Azo by Kodak and Cyko by Ansco, all introduced before 1905. Others included Artura (acquired by Kodak in 1909); Noko, Monarch, and Royal by Ansco; Kruxo; Defender; plus a variety of lesser known labels.[40] Azo was slightly less expensive than Velox, and of all the postcard paper stocks, seemed to be the most popular.

Cyko, one of the earliest postcard papers, offers both "normal" and "professional" grades in its manual of the early 1900s. Like Kodak, Ansco imprinted the paper with photographers' or sellers' names without charge for large orders of five thousand or more. The company describes its product and provides detailed instructions for making the postcards as follows:

The manipulation of Cyko postal cards is similar to that for making Cyko prints. The cards are sensitized on one side only, and the other side is printed to conform to the postal regulations. The negatives should be selected the same as when printing with Cyko paper. A printing frame and glass a size larger than the negatives should be used, and a mask employed to produce a white edge on the print. The mask is placed between the negative and the sensitized side of the postal card. On exposing, developing and fixing the card, the same result is obtained as with an ordinary sheet of Cyko paper, viz.: a picture surrounded with an edge of the part which was protected by the mask.

Cyko postal cards are furnished in three surfaces: Glossy, Semi-Matte and Studio (velvet surface).

There are many ways of making the Cyko cards lie absolutely flat after drying. One method is as follows: After removing the superfluous water, place the postal cards, face up, on a sheet of blotting paper; then place on this layer of cards a piece of cheese cloth; and so on alternately. Then put them all under pressure until dry. Another way is to sponge the cards, after drying, with wood alcohol, and then to allow them to dry under pressure.[41]

The manual continues with instructions for "Double Printing," which describe how to provide "artistic" rectangular or oval frames within the postal print.

The "Graber," a non-Kodak product made in Britain, was an "automatic, exposing, type-printing, and cutting machine" that printed text and photograph on rolls of postcard paper and then cut them into individual postcards. It remained available in the United States as late as the 1940s. A 1912 advertisement reads:

This well-established and famous post card machine is in use in all parts of the world, giving entire satisfaction. This well-known machine will be

found a most useful investment for a large or small business for publishing real photographic post cards. Can be worked either by hand or by motor.[42]

Such a machine clearly indicates that some photo postcards were produced on a large scale, most likely in cities, tourist destinations, and resort areas.

In 1914, Kodak introduced its Autographic camera, which was followed by various models, including the 3A Autographic. Although not a great success, the Autographic was hailed—as many new Kodak products were—as "the greatest Photographic advance in twenty years." To the amateur photographer, Kodak said:

> You can now date and title your negatives, permanently and almost instantly at the time you make them . . . Any picture that is worth taking is worth a date or title. The places of interest you visit, the autographs of friends you photograph, interesting facts about the children . . . all these things add to the value of a picture. The careful amateur photographer can improve the quality of his work by noting, by means of the Autographic Kodak, the light conditions, stop and exposure for every negative.[43]

The autographic camera had a small door in the back that lined up with the margin between film exposures and opened so the photographer could inscribe with a pencil or stylus on two layers of paper backing—on top a thin red paper, and below, carbon paper, with carbon side up. The carbon was removed where inscribed, allowing the light to pass through and expose the film beneath. Thus, whatever words or coding the photographer added could be printed with the image if desired. Occasionally, we find such inscriptions on photo postcards.

From 1902 on, Eastman constantly urged his dealers to encourage postcard production among amateurs and developed advertising campaigns to this end. Kodak had its own line of advertising postcards, introduced in 1908 and continuing until as late as 1916. These cards usually had a photo image of "the Kodak girl" with a 3A camera on the front and a preprinted handwritten promotional message on the back. At first glance, each appeared to be a personal, individualized postcard. They could be ordered in lots of four hundred or more with the supplier/dealer's name and address for mailing to customers.[44]

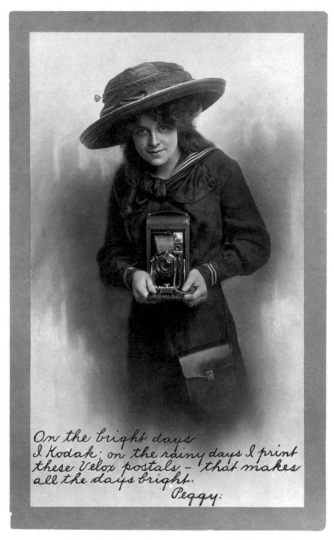

On the bright days I Kodak; on the rainy days I print these Velox postals - that makes all the days bright.

Peggy:

*Kodak advertising postcard with facsimile
handwritten message. 1911.*

"Your own vacation fun will be doubled if you take along a Kodak to photo-
graph the interesting places and people and the folks at home will enjoy the
Velox postals you can send them. It's all very simple—no dark room you know.
Let us show you.
Sigurd Landstrom, Lebanon, Oregon"

George Eastman's genius was to recognize and encourage the vast po-
tential market for photography, a market he understood to be primarily

that of the "novice" amateur whom he called "Kodaker." His company innovated to meet that market and when innovation was identified elsewhere, Kodak quickly moved to acquire or to protect its market through aggressive patenting. Eastman brought Kodak into American neighborhoods and took it worldwide, dominating the market for popularly priced cameras and photographic products. The 3A camera produced huge quantities of photographic postcard images. To "read" the backs of "real photo" postcards is to appreciate the company's dominance: most carry the trade names of Kodak postcard paper stock.

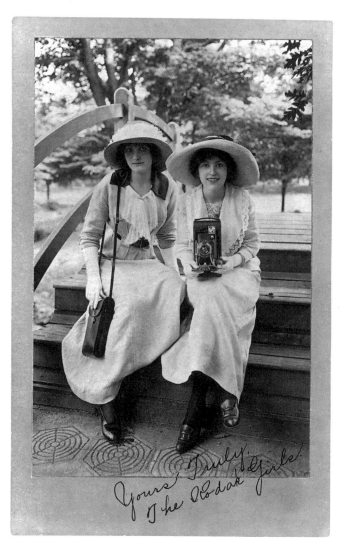

The Kodak Girls. 1913.

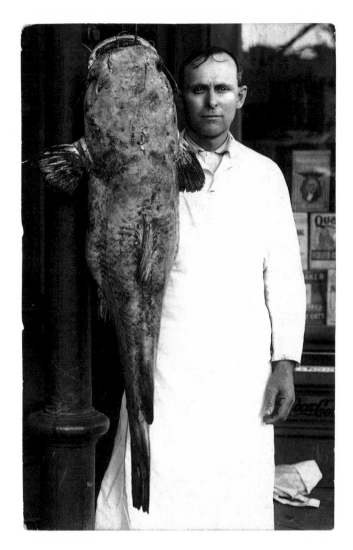

1910—1918.

[CHAPTER SIX]

"REAL PHOTO" POSTCARDS: INFLUENCES, USAGE, MAKERS

IMAGINE a time when a kind of popular communication could be called "real photo." On one hand, the name seems quaintly resonant of a bygone era; on the other, such a label could make sense today. One impetus was surely to distinguish the genuine, original photographic print from the multi-image reproduction. The abundance of mass-produced postcards flooding a popular market is analogous to the glut of print materials in our own society, when an original photographic print is likely to be restricted to art object, professional portrait, printer's original "camera-ready" copy, or snapshot. The "real photo" postcard was different from the majority, and the name identified that difference. The black and white photograph was real and also proclaimed that color did not necessarily heighten reality. Inherent in the photograph was the presumed truth of its contents. It is this "reality" and the trust it implies that seem almost unimaginable today.

"Real photo" makers must have been influenced by the images and information around them. Outside major cities, halftone reproduction was not yet widely used in the print media, so illustrations took the form of wood engravings, often based on photographs but not tonal reproductions of them. Certainly, portrait photographers often followed traditional portrait models, and images in lithography and photography were on parlor walls and table tops. Makers deviated from existing models, however, as the audience or subject narrowed to a particular individual, event, building, or workplace—when the cards became personal. Photographers, including postcard photographers, used the camera to please the client, to capture the image as best they could. While some established

61

publications for ambitious amateurs and professionals—such as *Camera Work*, *Camera Craft*, and various camera club periodicals—showed little or no interest in "real photo" production, other journals such as *Camera and Darkroom* and *American Amateur Photographer* offered advice and instructions for making "real-photo" cards.[45] And, as we have seen, Eastman Kodak and others promoted postcard production with products and information.

The relative scarcity of photographic postcards does not mean there is little material available. Although far outnumbered by mechanically reproduced early-twentieth-century postcards, "real photo" cards may still be found in the marketplace, family albums, and historical archives. The value we assign to them now is heightened by the passage of time and by our own contemporary culture, when we are especially conscious of past and future at the start of a new millennium. Collectors avidly search out photographic cards, and good examples command more than a few dollars. Scholars and museums are beginning to pay attention to them.[46]

My own analysis of "real photo" postcard production suggests some generalizations about usage and production. First, many cards were never mailed. This seems true for postcards in general; many were saved and collected as souvenirs just as they are today. One can argue that the unmailed cards were most likely to remain in good condition, yet vast numbers of well-preserved postcards survived the handling of the U.S. Postal Service. "Real photo" cards were frequently given directly to a friend or family member, put in albums, and preserved as a record or memento. The majority of the cards I have seen were not mailed and, while sometimes annotated, bear no address, postmark, or stamp. Approximately one-quarter of the postcards illustrated here were stamped and mailed. If one includes cards with notes or messages suggesting they were sent as enclosures, that number increases to approximately one-third.

While many photo postcards were apparently produced by professional photographers, few bear the signature, stamp, or imprint of a specific photographer or studio. Often, the subject photographed is identified, but the photographer is not. This is consistent with the majority of mechanically produced postcards. Seldom is the photographer credited, although names of publisher/manufacturer and subject/title are usually included on the card. Most "real photos," however, bear no such attributions. When the maker is identified, his (and occasionally her) logo or signature may be

scratched or written on the glass plate or written on the film negative to appear within the photo print. Or the identification may be embossed in the paper. More often, the photographer's identification is stamped or printed on the back of the card. Kodak, like Ansco, offered the latter service, with the price dependent on the quantity of stock ordered. From a 1908 *Kodak Trade Circular*, for example:

> Printing on Atlantic City or Plain Post Cards: When ordered in lots of not less than 5,000, the photographer's name and address will be printed in regular type on end of card free of charge. When ordered in less than 5,000 lots, name and address will not be printed, except at the regular price as stated above. ($1.50 net for the first 1,000; subsequent orders per 1,000, $.50 net; and no order accepted for less than 1,000.)[47]

The anonymity of so many photographic cards combined with the growth of amateur photography tempts us to see many of these cards as amateur production. We cannot be sure, but probably most were made by professional photographers, some by skilled amateurs, and still others by less experienced practitioners whose snapshot prints took postcard form.

An account of early Kodak photography contrasts the snapshot with the professional portrait, suggesting that the latter shows how people looked when they wanted to make an impression. The snapshot, on the other hand, presents them as they *were*.[48] Such amateur cards may often be identified by subject matter, their relaxed and casual nature, the quality of their photography or printing, their implicit complicity with intended audience, and sometimes, their written message. Often, the nature of production is uncertain, and we are left to wonder who indeed created the image.

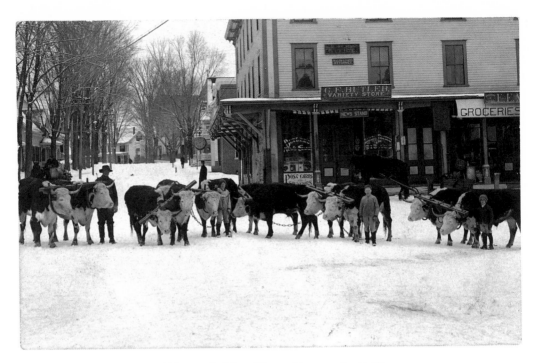

Hillsborough, New Hampshire. 1910–1918.

¶ Notice the Post Cards sign in the variety store window.

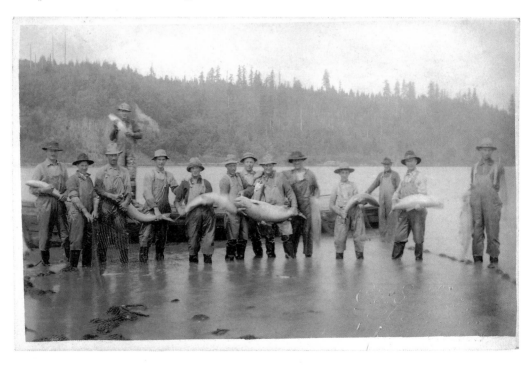

Oregon. C. P. Sutfin photo. Westport, Oregon. 1912.

"How's this for salmon? Did you get as big a haul of crab?"

PART TWO

◆◆◆

Real Photo Subjects

The postcards that follow are among the best I found of such common subject areas as views, topical news, events and celebrations, portraits, home, work, play, and transportation.

For dating, I use various sources. Some "real photo" cards are dated by the photographer; some carry a postmark; some are dated by message or annotation, or by clues in the message or image. Photo postcard paper stock trademarks also convey dating information, and for this I rely primarily on the appendix in Hal Morgan's and Andreas Brown's pioneering book on American photographic postcards, *Prairie Fires and Paper Moons.*[1] When I identify location, it is usually by image, caption, postmark, or message. When the postmark is partially legible or ambiguous, I use *The Real-Photo Locator* by George C. Gibbs, a guide to U.S. post offices during the "real photo" era.[2] To identify the maker, I use whatever the photographer provides on the face or back of the card for studio, name, or logo.

I invite the reader to join me in looking at each card. A photographic postcard is a complex object. It is historically specific; it is a tangible product or commodity; it is the maker's construct; it reflects the subject's search for status or satisfaction; it exists in a larger context. It was available to its contemporary viewer and carried meaning and associations then; it offers signs for reading by subsequent viewers and by us now. Each card has its particular character and visual message. Each reflects its era and locale, and serves its audience or buyer. Each photographer approaches his/her subject in a particular way. Some images make an obvious point; some provoke comment and question. The more one looks, the more one sees. Other viewers may see more and see differently. Content is not an absolute. The photograph is only a moment, after all, and one seen in isolation. "Real photo" cards, while a modest kind of photo production, raise all the complex issues associated with image making and photography.

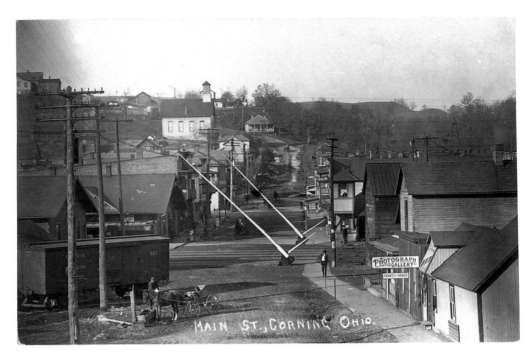

Corning, Ohio. 1907–1912.

¶ Corning's Photograph Gallery with skylights sits on Main Street at lower right.

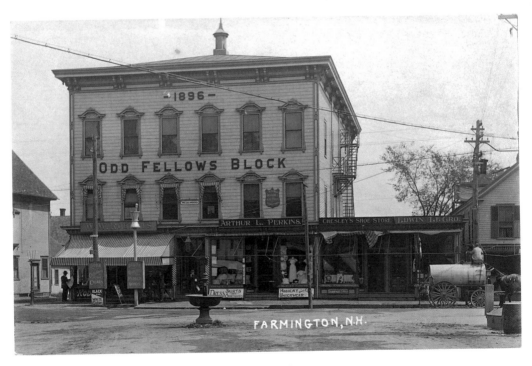

Farmington, New Hampshire. 1913–1914.

¶ Note the water wagon at right and Kodak signs under the awning at left.

VIEWS AND THEIR MAKERS

Most prevalent of all postcard subjects, whether photomechanical reproductions or "real photo," are views of towns, cities, resorts, and popular sites. Produced by professionals, photographic views were sold to tourists, visitors, and local residents in souvenir and novelty shops, drug stores, and newsstands. Like traditional painted landscapes, the format was usually horizontal. Valuable records of places, postcard views conveyed the status associated with travel and expressed pride in the local community. They were also souvenirs, offering memories of specific places or events. Today, they have much to tell us, not only about how a particular place looked at a particular time but also about the period's social and cultural values.

In the case of small-town "real photo" views, the photographer was often itinerant, traveling by train, bicycle, or horse and wagon to photograph characteristic views. Some towns had their own photographers who kept busy with local and regional work. Whether the photographer was local or itinerant, views may have been only a part of his practice.

Small-town view cards were tied up in boosterism and local pride. It is almost as if the photograph conferred status and possession, and a place is rediscovered through its photographic image. A major celebration, such as a town's bicentennial, was the occasion for "real photo" production on a grander than usual scale. Still, the market was finite and local, ideally suited for the hand-production of the "real photo" maker.

Wheldon Storrs Harriman (1885–1975) was an itinerant photographer who worked out of Columbus, Ohio, from 1907 until about 1920. Train or bicycle carried him to the hamlets of central Ohio where he established relationships with local purveyors who advised him on what to photograph and how many copies of each image were likely to sell. In 1972, Harriman's family gave his records, glass plates, and more than thirteen hun-

dred postcard prints to the Ohio Historical Society where they form a re-markable record of central Ohio during the early 1900s, and offer a case study of a photographer specializing in small-town "real photo" views.[3]

Harriman's son, Glenn, said that his father worked as a traveling pho-tographer after he married in 1907 and photographed local events such as funerals and the Dayton and Columbus floods of 1913. Glenn, born in 1923, said his father's itinerant work was over by then, but remembers his father working with photo-processing chemicals at home, until a badly in-fected finger put an end to that practice. Soon thereafter, the camera was used only for family photographs, and the gallon jugs of developing fluid and boxes of glass plates were stored away in the basement.[4]

One camera used by Harriman and now in his son's possession was a Kodak Film Pack Premo for 3A film with a patent date of July 1913. Made to be used with either glass plates or celluloid film packs, Harriman's cam-era had an attached wood plate holder indicating he used glass plates.

A close look at the materials in the Harriman Collection helps us un-derstand how this view photographer and others worked. Prior to acquir-ing the 3A camera, Harriman must have used a large folding view camera to make postcard images that he cropped to postcard size. He identified both plate and print with a number (often scratched in the corner of the emulsion surface of the plate with corresponding number written in ink on the face of the print), then sent off a set of numbered postcard prints to his clients. These photographed views would be returned to him with identifications, special instructions, and the quantity ordered written on the back of each card. Harriman's usual next step was to write identify-ing titles in black reverse lettering on the glass plate, positioning the words to fit within the intended cropping. End result: a carefully cropped image with a caption in white toward the bottom of the photograph.

The annotated cards and related correspondence in the collection bring the small-town view photographer's business to life and demonstrate the popularity of these local images. Although occasionally a client requests "colored" or "tinted" cards, most want "plain" or uncolored images. The usual order for Indian Lake, for example, is "25 plain," with the exception of one hotel for which fifty cards are ordered.

Pataskala, too, is a "25 plain" kind of town. Bridge, churches, Main Street, residences, bird's-eye views, high school, the Silent City (cemetery), railroad depot, and Pataskala Mdse. Co. are all ordered in that quantity.

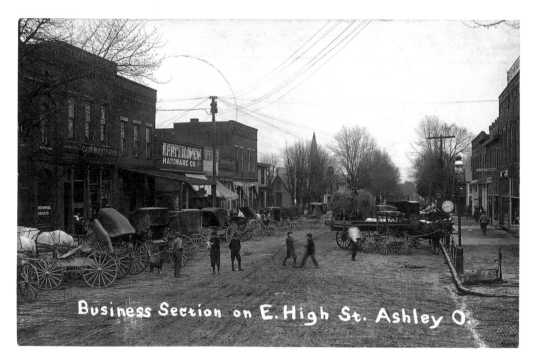

Business Section on E. High St. Ashley O.

Ashley, Ohio. Harriman postcard. 1914.

"Dear Sister, Will accept your invitation and leave here at 8:13 AM Friday. Do not know just when I will get through. Frank."

Only the building that houses both the "Mdse. Co." and the post office merits an order of fifty.

New Washington, Ohio, clearly offers a popular market for local views to its German-American population; there, minimal orders jump to one hundred. Mansfield Street, the William Derr residence, S. J. Kibler & Bro. Co. Plant, S. J. Kibler residence, Public School, and Uhl Hatchery are all ordered in quantities of one hundred each. Kibler Street weighs in at two hundred, and the Lutheran Church at three hundred, one of the largest orders found in the Harriman archive. Even the splendid firetruck from Greenfield, Ohio, inspired an order of only two hundred.

A few cards are marked "out of date." From Chatfield, Ohio, comes an order for "50 plain, 50 colored" and on another is written "Throw out." The Milford Center R.R. Depot says "No printing on this," doubtless because the town name is highly visible on the depot wall. On a tinted card

from Waldo, Ohio: "Colors all right except the house marked x should be yellow and the one next to it white." From Buckeye Lake: "Mr. Harriman, please finish 75 of these cards and mark them Minthorn Hotel."

With an order for twenty-five postcards of the Big Darby Bridge comes an additional note: "My girl moved. If you can improve her appearance any, kindly do so." Sure enough, at the entrance to the bridge stands a blurry little figure, but even Mr. Harriman at his most accommodating cannot satisfy this request. Other enhancements are occasionally made, probably at the client's request. Harriman, for example, applied printed signage to a three-story brick building in Canal Winchester, Ohio. The satisfied customer notes on the back of the card: "300 taken like sample with printing on. Will order more if you make us a good one."

By the mid-to-late 1920s, apparently no longer doing photography for postcards, Harriman had a novelty business in downtown Columbus that included postcards. His invoice from that time reads: "W. S. Harriman, Publisher and Wholesale Dealer in POSTCARDS, Greeting Cards, Valentines, & Season Novelties." He did not list himself in city directories as photographer, nor does he identify himself on the postcard as photographer or maker. But his name does appear from 1915 to 1922 in Columbus city directories under a listing for Wholesale Postcards, indicating that by then he saw his trade as postcard maker or supplier, not photographer per se.

It was not unusual for photographers to modify or add to the image as Harriman did, though most often, such manipulation appears in photomechanically reproduced postcards rather than in "real photos." Thomson & Thomson, a Boston postcard publisher, sent original photographs to Germany for printing. In one typical instance, the publisher asked to have an automobile added to a Cape Cod scene, so an automobile decal is inserted in the printed postcards.[5] Decals of automobiles and flying machines turned up in "real photo" views, but worked particularly well on photographs that served as original artwork for mechanically reproduced postcards, because the deception wasn't obvious in the end product.

"Real photo" cards could revel in the camera's ability to play tricks and such tricks took different forms. Photo studios at popular tourist sites offered "swimmers" the opportunity to be photographed in bathing costumes on a sandy beach or with heads bobbing against a backdrop of rushing waters. Sometimes photographers played with multiples, show-

ing the same individual seated repeatedly around a table. These images fooled the eye until it clicked that each person was the same and that reflections in carefully angled mirrors produced the deception. "Exaggerations" were another genre of trick photography. Its best-known practitioner was Kansas's W. H. Martin, who in deadpan fashion via careful photomontage combined oversize fish, animals, fruits, or vegetables with people in everyday situations to dramatic or humorous effect. Martin also staged reenactments of scenes such as Indian battles, persuasively real yet decades too late to be authentic. Such manipulation, however playful, reminds one that a "real photo," like any photo, is not necessarily true; that visual reality in the image is not always what it seems to be; that the market, the maker, or technology can skew the product.

A 1912 view of Main Street, Chatham, Massachusetts (population then about sixteen hundred), is transformed into a futuristic scene showing elevated rail, streetcars, subway, and airplanes converging in the town's center. While humor and playfulness are in the mix here, this card reflects a time of technological change and progress felt even in such a village as Chatham. The year 1912 marked the two-hundredth anniversary of the town's incorporation, which was celebrated in August of that year during "Old Home Week," a phrase often used to describe small town anniversary celebrations. Perhaps this card was inspired by the bicentennial.

By the second decade of the century, this Cape Cod fishing village had become a popular resort town, attracting summer visitors from off-Cape. Chatham had its own railroad station; telephone service had been introduced and party lines were coming into service; town meeting would vote in 1912 to contract for electricity; the Orpheum Theatre would bring moving pictures to Main Street in 1914 while Marconi wireless towers— soon to be obsolete—were being built at the edge of town. By 1918, the Naval Air Station located between Chatham and Orleans was operative and sending planes and airships into the air to patrol for German submarines offshore.

The Richardson Studio is responsible for many views of Chatham. "Only a Dream" is atypical, yet it expresses some ambivalence about progress that may have been shared by other small towns at that time. The studio, shown on a 1907 map of Chatham, was just off Main Street and may be seen next to the trolley in the "Dream" postcard. When the block was rebuilt in 1914, the studio was sold and may have moved to

"Only a Dream." Richardson Studio, Chatham, Massachusetts. 1912.

¶ The century's second decade was indeed an exciting time of progress and change, represented here in this fantasized urban scene with its wry title showing artist-drawn rail transportation and decals of early airplanes above the town's still unpaved Main Street. Although the ocean isn't shown, other aspects of the natural environment have been intruded upon: rails on, above, and under ground; planes in the sky. The subway announces that the city, Boston, isn't far away. What is Chatham's world coming to? Where does "reality" begin and end in this "Dream" image?

nearby premises in the Mayflower Shop. Numerous "real photo" cards bear the Mayflower Shop or Studio imprint, sometimes with the name of another Chatham photographer, Charles Smallhoff. We know little else about the person or persons who comprised the Richardson Studio, but we do know that the studio emphasized the summer resort trade, producing postcards showing various views of the town, its streets, vistas, shorefront, special buildings like the new movie theatre, and events like the two-hundredth anniversary "Old Home Week."[6]

Resorts and big cities had a different audience from that of small-town

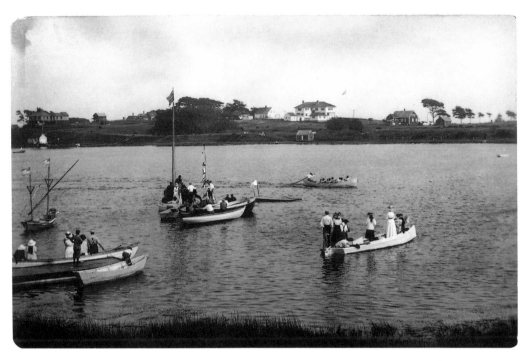

Lifeboat races on the Mill Pond. Old Home Week. Richardson Studio,
Chatham, Massachusetts. 1912.

¶ The celebration included special church services, lifeboat drills, sailing and dory races, ball games, a concert, an outdoor banquet, a parade, a ball, and fireworks. Here, well-dressed spectators watch lifesaving boat races on the town's broad Mill Pond, with crews competing from the four local lifesaving stations. The water is where the action is: both oarsmen and spectators are in the water. Chatham is thus shown simultaneously as an elemental sea town and a picturesque seaside resort.

U.S.A. Their audience consisted of tourists, travelers, and visitors whose implicit message was: I was there; this is where I vacationed; this is what it's like. Or for residents, this is *my* town; this is a place worth coming to. For visitors, status and sophistication were associated with travel. For locals, pride of place was enhanced by postcard images.

While mass-produced postcards competed with "real photo" cards in popular destinations, some establishments produced large quantities of photographic cards. An individual photographer's or company's style was often recognizable through characteristics such as quality of light, human

presence or absence, depth of field, framing, or captioning. In the northeast, Eastern Illustrating and Publishing Company of Belfast, Maine, established in 1909, seemed ubiquitous. For more than three decades, their imprint appeared on views throughout their home state, plus New York and much of New England. In *Roadside New England*, R. Brewster Harding describes the company's business and history. Salesmen-photographers were dispersed throughout the region with Graflex cameras and glass plates to sell views and to photograph new selections. Back in Maine, titles were added to plates in washable black ink that allowed for easy change as needed. Working much as Ohio's Harriman but on a far bigger scale with a large photographic, sales, and production staff, Eastern tailored production runs to local outlets for the summer market, printing the cards on precut postcard stock.[7] The White Mountains of New Hampshire, the Adirondacks in New York, and resort areas throughout the country were widely photographed by local photographers who made postcards to sell to recreational visitors.

The camera, and access to a high or overlooking vantage point such as a hillside, water tower, church spire, or occasionally even an airplane, provided a new and popular way of seeing. This new perspective could show the big picture—a whole town or section thereof. The viewer's gaze, the camera's eye, captured all. That such a view could be miniaturized and sent through the mail, held in one's hand, or tucked in an album was truly empowering.

Nowadays, "real photo" views—mostly by unknown photographers and sometimes unidentified—are archived by collector-historians, local libraries, and historical societies. They offer an invaluable record of place and life at a particular time. Small-town views often precede the presence of the automobile, movie theaters, sometimes even the telephone or electricity. Roads are frequently unpaved. Dating, seldom recorded by the photographer and not always apparent through the view itself, can be fairly reliably assigned by postmark or message date. Especially helpful, considering the number of unmailed or unwritten-upon cards, is the photo stock itself. The divided back only appeared on U.S. cards after March 1, 1907, and paper trademarks can be keyed to specific years of production. While not infallible, these markings are generally a useful guide for dating.[8]

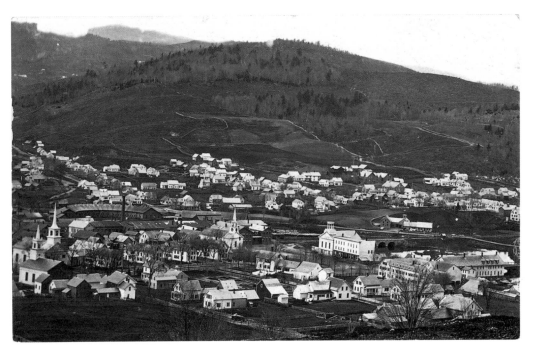

New Hampshire town. 1907–1912.

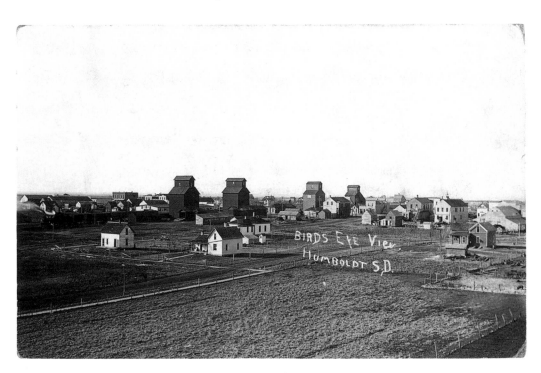

Humboldt, South Dakota. 1908.

75

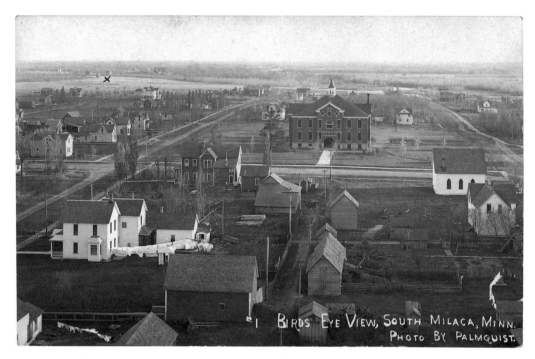

South Milaca, Minnesota. Photo by Palmquist. 1910–1918.

"Where I put the cross our farm lies."

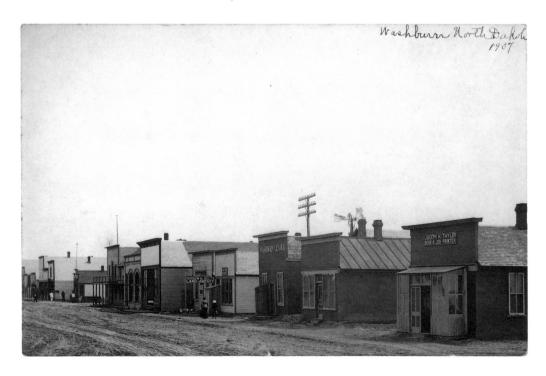

Washburn, North Dakota. 1907.

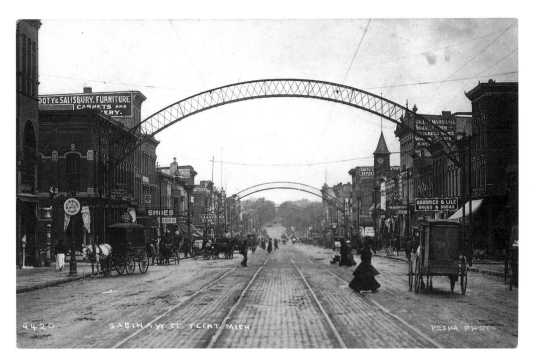

Flint, Michigan. Pesha Photo. 1910.

Brooklyn Bridge. New York. 1910–1918.

Presbyterian church. Middle Granville, New York.
Photo by Moore & Hayward, Rutland, Vermont. 1906.

¶ This early card carries message and image on the front, and only address on the back.

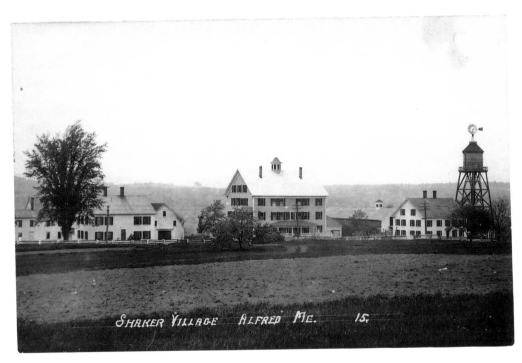

Shaker Village. Alfred, Maine. Eastern Illustrating & Publishing Co.,
Belfast, Maine. 1913–1915.

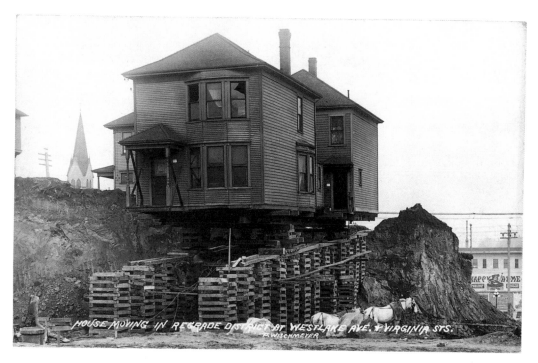

House Moving in Regrade District. Seattle, Washington. P. Wischmeyer. 1909–1910.

¶ Seattle's population tripled between 1900 and 1910. In the "Denny Regrade," Denny Hill was cut away to create a new topography and building sites.

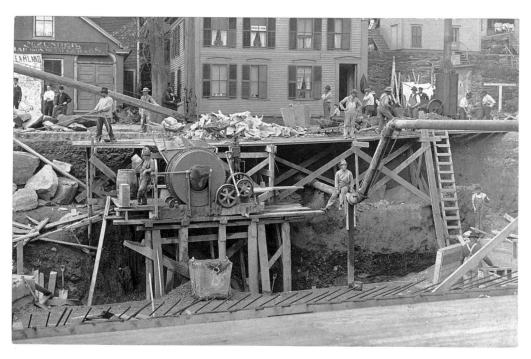

Urban excavation. Unknown city. 1910–1918.

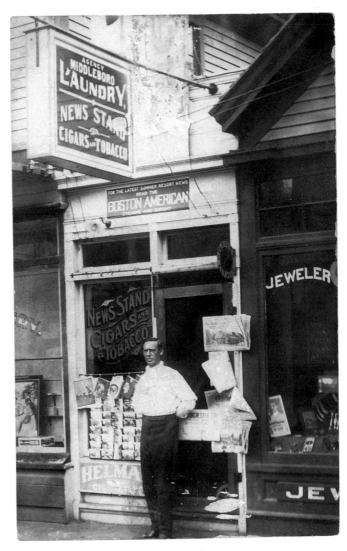

Newsstand. Middleboro, Massachusetts. 1909–1912.

¶ Signage, print materials, and individual enterprise are packed into this shop portrait of storefront and proprietor. The photograph confirms his status and advertises his wares, which include news, tobacco, and postcards.

[CHAPTER EIGHT]

NEWS

IF views constituted the lion's share of real photo production, it was the remainder that provided dramatic content. Events, politics, celebrations, and disasters were all subjects for the "real photo" photographer, for they had news value. Small-town newspapers of the early 1900s still relied upon wood engraving for illustrations, if they had them at all. One can imagine the impact of a "real photo" card that could be purchased soon after the event, sent to a friend or relative, or simply held onto for its dramatic news value. While the technology to combine photographs and type in the print media through halftone dot reproduction was available by the 1890s, such advances—like many other technological ones—had little impact outside major cities until after World War I.

The images that follow are the stuff of memories as well as news. The postcard reminds its owner of the event, associates him or her with something important that happened: "I was there" or "I remember." It proclaims status and memory.

FLIGHT AND CELEBRITY

There was much excitement about flight at this time. News value and celebrity accompanied early flight, whether risky performance like barnstorming and "aero meets" or dangerous, pioneering ventures like longdistance flight. The Wright brothers' *Flyer* had briefly lifted off the North Carolina beach in 1903, and during the next decade the public became infatuated with aviation. Early-twentieth-century aviators became American heroes and photographers eagerly recorded their exploits.

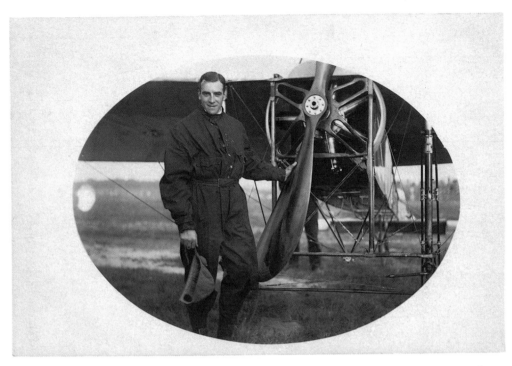

British aviator Claude Grahame-White with his Blériot monoplane at the Harvard Boston Aero Meet. Moehring & Groesbeck Post Cards and Art Novelties, Lynn, Massachusetts. 1910.

¶ This was the largest aviation event held in the country up to that time and many famous aviators attended. Aviation clearly captured this postcard firm's interest. Printed on an envelope from successor firm Groesbeck & Allen of Lynn is the following promotional message: "Genuine hand made photographs. The finest in the land. An additional set of twelve interesting aviation photographic postcards mailed to your address upon receipt of fifty cents (50c)."

¶ *(facing page)* Barnstormer George Schmitt was photographed in his biplane both on the ground and in the air at the Labor Day Fair in Rutland, Vermont, before his fatal accident later that day on September 1, 1913. The two postcards are not addressed or postmarked, but as their brief messages from the same sender show, they were probably sent as enclosures in an envelope. In the second image, the photographer duly inscribes date and identification on the negative so that this information is printed in every postcard positive.

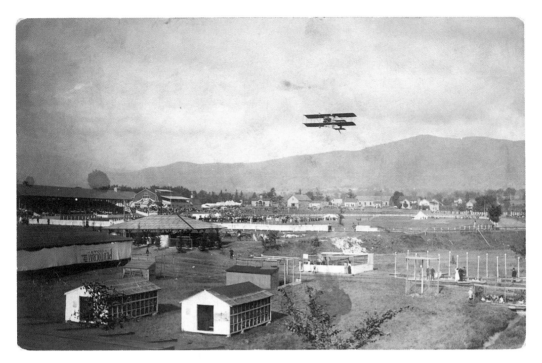

George Schmitt's biplane, The Red Devil, *in flight. Vermont. 1913.*

"This is Schmitt flying the day he was killed."

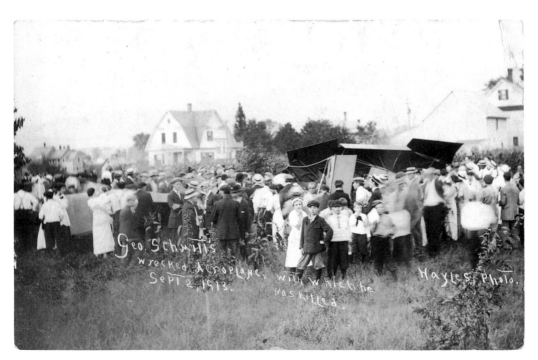

Schmitt's wrecked aeroplane. Hayles Photo, Rutland, Vermont. September 2, 1913.

"After the accident—all well hope you are the same, Elsie."

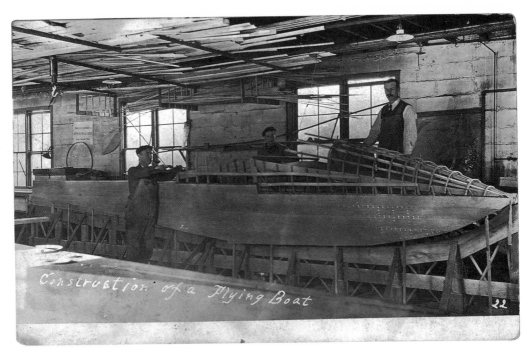

Construction of a flying boat. Hammondsport, New York. ca. 1913.

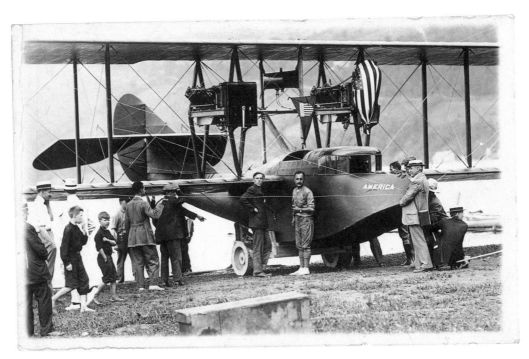

The America. *Hammondsport, New York. 1914.*

¶ Designed by G. H. Curtiss (with mustache) for transatlantic flight in 1914, the "flying boat" *America* eventually crossed in 1918. Informal camaraderie is in the air, along with optimism and national pride conveyed by the name of the aircraft and the stripes flying above her.

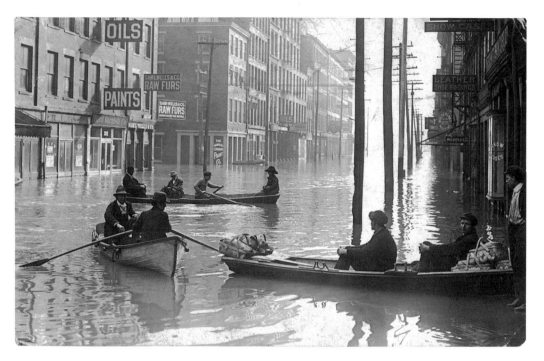

Cincinnati, Ohio. 1913.

"Dear Tolka, I am alright. I am about seven miles from the flood but I have been down to see it. I have to stay here for a while longer for I cannot get to St. Louis until some of the bridges are built. I hope your arm is alright and that you are going to school again. I miss you every day more. This is a good picture of the streets of the flood district. The river is going down. Love to all of you. B. Conroy."

¶ Many "real photos" were made in Ohio during the heavy flooding of the spring of 1913.

DISASTERS

Fires, floods, natural disasters, and train, ship and car wrecks constituted news and were bread and butter to the local photographer who quickly made up newsworthy "real-photos." Sometimes he was on hand to capture the event itself. More often, he recorded its aftermath.

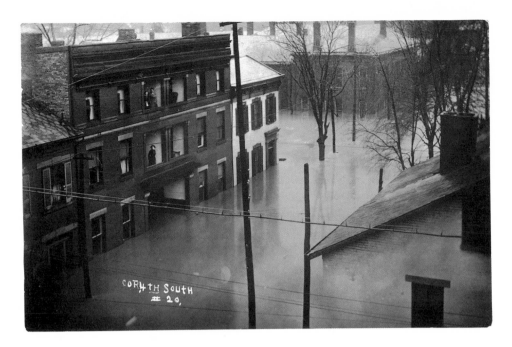

Zanesville, Ohio. 1913.

¶ Three women stand motionless in upper windows, the only visible human presence in the flooded town.

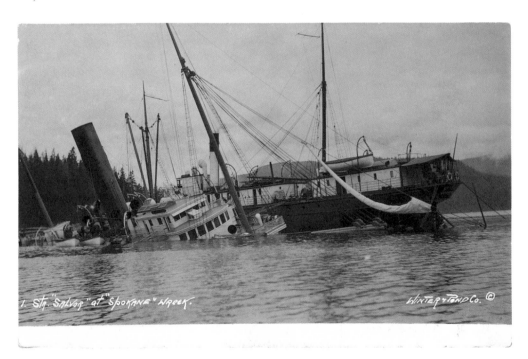

Wrecked ships. Winter & Pond Co. photo. Juneau, Alaska. 1912.

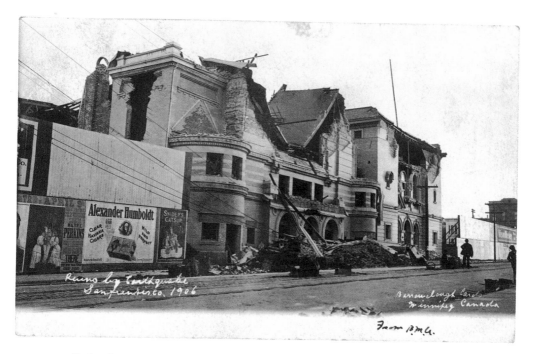

*Ruins from Earthquake. San Francisco, California. Barrowclough Cards,
Winnipeg, Canada. 1906.*

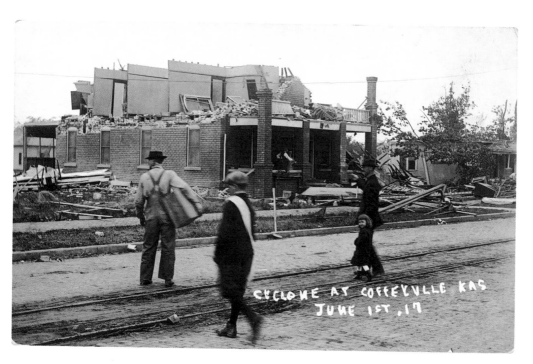

After the cyclone. Coffeyville, Kansas. June 1, 1917.

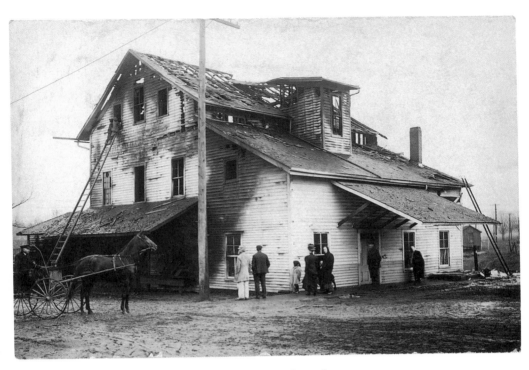

Curious visitors after a fire. 1910.

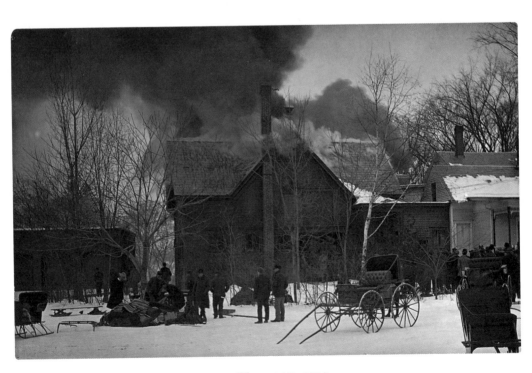

Fire. 1907–1910.

¶ The smoke is dense and oppressive, but there is psychological weight, too, in this image—a sense of helplessness, inevitability, and potential disequilibrium.

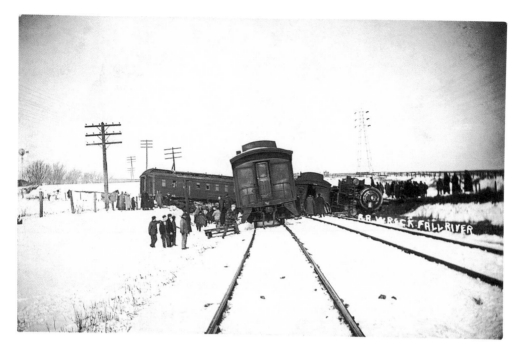

Train wreck. Fall River, Massachusetts. 1912.

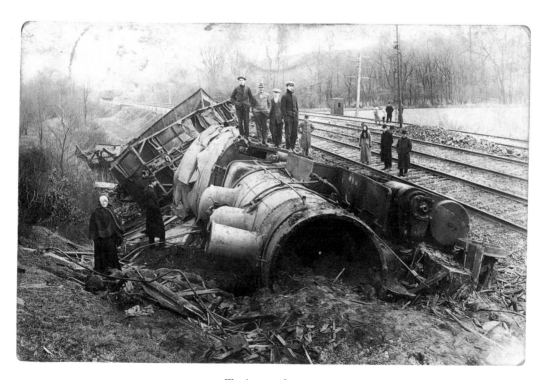

Train wreck. 1912.

"This wreck occurred Friday evening Dec. 13, '12, at 5:20 P.M. at the east end of the cut . . . A west bound freight plowed into a freight that was standing with the rear end east of the mouth of the cut. The Engineer was killed instantly."

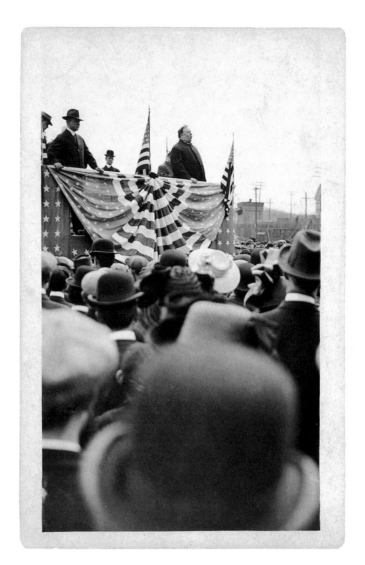

President Taft speaking to crowd. 1910–1912.

¶ A note on the card refers to secret service men on the platform. We don't know where this speech occurs, but the president commands a good crowd. The photographer has taken a dramatic picture: Taft's impressive form, flanked by flags above draped bunting, is silhouetted against the sky. Unlike the others, he is hatless. We stand behind a blurry foreground bowler, but the camera's focus and our eye are on the speaker.

LOCAL EVENTS

The postcard often reports a significant local event, sometimes a political one. Presidential visits, rallies, riots, demonstrations, and parades were then—as now—of considerable local, regional, and even national interest.

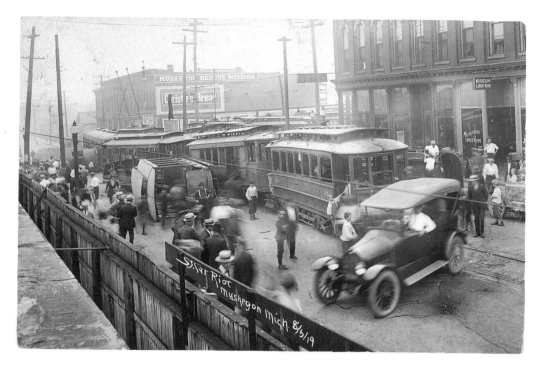

Streetcar riot. Muskegon, Michigan. August 5, 1919.

"Had a serious riot here Tues. eve—and about all street cars demolished so we have no cars running now, due to raising the fare to 7c. A number of people were injured and one died. Cars were seized and sent crashing into each other all evening and night. This view is on one of the corners the next day."

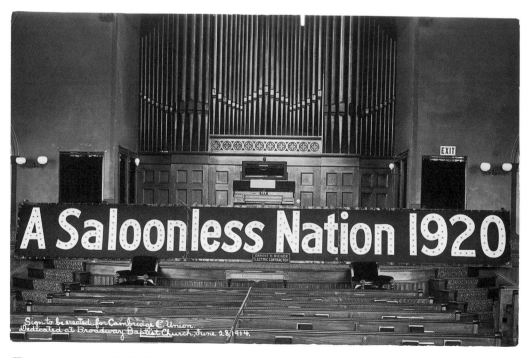

Temperance sign. Cambridge, Massachusetts. Photo by Herbert E. Glasier & Co. Boston. 1914.

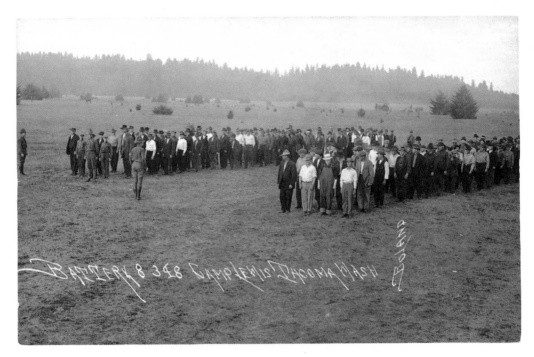

Battery 8 348, Camp Lewis. Tacoma, Washington. Boland, photographer. 1914–1918.

Nebraska. 1909.

"Dear Cousin, On the other side you see your honor as a military man, not very fierce. What do you busy yourself with in these strenuous times? We are cutting grain now. . . . I had a nice ride in a touring car last Sunday afternoon but believe I prefer a carriage with just room for two . . . Goodbye, Walter."

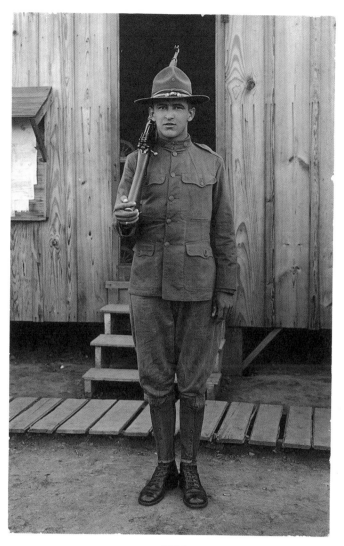

ca. 1918.

WAR

War is always news. On photo cards we find images of soldiers and sailors, ships, military camps, hospitals and parades. Some relate to World War I, but others reflect relations with Mexico. Many of these images were made in this country. Others, often on foreign photo stock, were made abroad and were intended for propaganda or morale building, or for sharing aspects of the experience with those at home. Military action is rarely shown. Occasionally, a narrative, such as a military maneuver or camp life, is revealed through a series of cards.

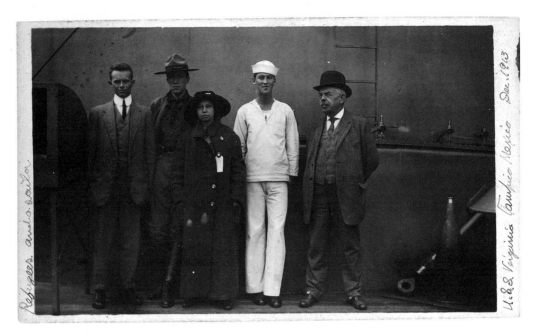

USS Virginia. *Tampico, Mexico. December 1913.*

"Some of the refugees on board the USS *Virginia.*"

¶ This is one from a group of photos taken off Tampico near Veracruz. Made by a ship photographer on the USS *Virginia* for crew members and annotated in the words above by one of the crew, these images document U.S. naval presence off the Mexican shore and show some of the American refugees.

A number of cards from 1913 and 1914 reflect deteriorating relations between the United States and Mexico at the time of the Mexican Revolution. In early 1914, the Mexicans seized a U.S. ship in Veracruz harbor; the United States sent in the Marines and occupied Veracruz from April to November 1914. Border relations and rising tensions in Veracruz were big news in this country. "Real photo" postcards made on naval ships stationed in the area documented some of the port activities, recording history in the making and providing crew members with souvenirs and the means to communicate news to the folks back home.[9]

Paul Vanderwood and Frank Samponaro, authors of *Border Fury*, make a compelling case for photo postcards as historical record. Focusing on the many cards made along the Mexican border prior to and during the Mexican Revolution, they describe one American's postcard venture at

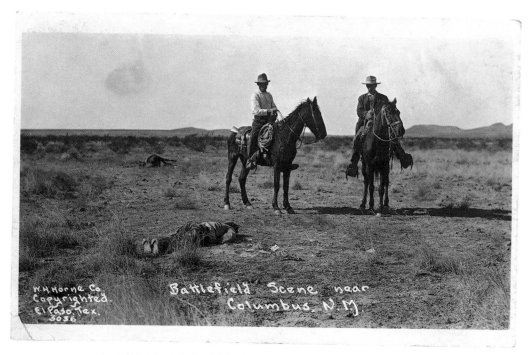

In-image text: W.H.Horne Co. Copyrighted. El Paso Tex. 3056 — Battlefield Scene near Columbus, N.M.

Battlefield with dead Mexican. Near Columbus, New Mexico.
W. H. Horne Co., El Paso, Texas. 1916.

¶ Playing cards scattered near the body suggest ambush during a card game and enhance the aura associated with Mexican bandits.

that time. From 1910 to 1917, Walter H. Horne's Mexican War Photo Postcard Co. produced "real photo" cards in El Paso, Texas, and sold them to the masses of troops concentrated along the border who sent them back to the States. Capitalizing on northern curiosity about things south of the border, these cards not only shaped public opinion but fed a sense of national superiority and appetite for combat and the perceived romance of the Mexican border campaigns. Horne, a "Mainer" who headed south in a boxcar, began more as an entrepreneur than as a photographer. He saw an opportunity, bought a camera, got himself into the thick of things, and managed to photograph Mexican and American weaponry, equipment, personnel, and even action. His postcard photos—which by August 1916 reached a production rate of five thousand in one day—conveyed news of the war and, beyond that, uniquely documented military operations and matériel used by the United States just before World War I.[10]

95

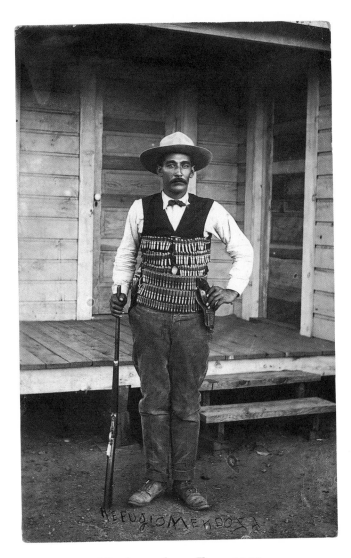

Mendoza refugee. Texas. 1918.

[CHAPTER NINE]

PORTRAITS: INSIDE THE STUDIO AND OUT

AMONG the richest and most appealing genres of American photo postcards is portraiture. The material truly speaks for itself. The people who comprised "real photo" production were its subjects, senders, savers. Thanks to photography, portraiture was no longer an expensive undertaking available only to the wealthy. Almost from the first moment, being photographed was an important ritual for Americans. Daguerreotype studios flourished, and a visit to a photo studio soon became a form of popular entertainment and recreation. What was this self-image making all about? It was surely in part an act of self-definition, status and validation. For many, during an era of massive immigration, it represented the creation and affirmation of a new American identity.

Postcard portraits were of groups and individuals. They occurred in formal studio settings or in situ. They were made by professionals and amateurs. And they included people of all ages, classes, and ethnicity; urban, small-town, and rural, although the highest levels of society seem least represented. Here, particularly, the complexity of photography comes into play, dependent upon the connection between subject, photographer, and viewer. The connection can be a powerful one in a personal portrait.

STUDIO PORTRAITS

Studio portraits were a distinct part of "real photo" production. Every city and many towns had photograph studios, and itinerant photographers could provide a studio setting out of a wagon or truck. Resorts offered extensive studio opportunities, making souvenir portraits available

to the vacationing visitor. Electricity, now beginning to be used for interior lighting, helped account for the popularity of the indoor studio shot.

In an article reprinted in the *British Journal of Photography* in January 1909, a professional portrait photographer from Salem, Indiana, offers his perspective on how to handle postcard sales:

> The sample of cards are kept well out of sight, but where they can be reached quickly, and, when a customer comes in, the regular work is shown and talked about, the order taken, the sitting made, and all business completed. If the time is propitious, the postcard question is brought up at that time, but, if not, the matter is not suggested until the proofs are returned and accepted. When the order is given, and the regular business all disposed of, then the samples of postcards are brought out with the suggestion that the sitter might have some friends who live at a distance to whom she might want to send a picture, but does not care to send one of the more expensive set. If so, the postcard, which can be obtained at two for a quarter, four for a half, or a dozen for a dollar will be just the thing, as it can be made from the same negative, and will be a pleasing little picture. The number of times this brings orders is astonishing and, as the cards are very inexpensive and easy to work, whatever is taken over and above the price of the original order is just so much velvet, and, in these days, if an average of 50 cents can be added to every order taken, it will make a very tidy sum at the end of the month.

He recommends:

> that the customer should get the best possible grade of work for the close friends and then send postcard pictures to those not so close, but not to think of changing the order to a cheaper picture. . . . If the cheap pictures are put out, the recipients, when it comes their turn, will very likely order the same grade as the one given them. . . . It does not pay to demand more than the customer can pay, but it does pay to give and to persuade the customer to take the best grade that he or she can afford. If the postcard is done shrewdly it is a fine thing. If it is not worked shrewdly it can become a nuisance. Do it right.[11]

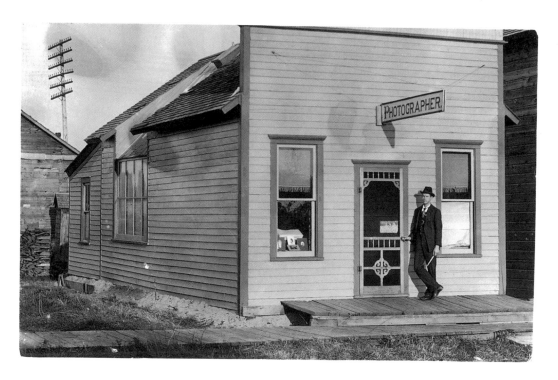

Photographer and studio. Phillips, Wisconsin. 1907–1914.

"Albert's gallery at Phillips, Wisconsin. Albert in photo."

¶ In this young photographer's window, we can see a selection of mounted portraits. The large side window and the roof skylight are deliberately included in the view in order to show the full extent of the studio facilities. Natural light was still key here, notwithstanding the towering utility pole which the photographer has chosen to enclose in his framing. Albert's postcard simultaneously announces his presence in the town as image-making professional and welcomes fellow townspeople to his place of business.

Studio photographs sometimes showed the subject in a neutral setting, vignetted or in an oval matte, standing or seated with a minimum of props. Often, the studio provided a chair to sit on, a table to lean against, or a pedestal on which to rest the hands. Some photographers replaced neutral space with a fabricated interior or landscape background in order to enhance the subject's status and connect the photograph with earlier

traditions of portraiture. The contrast between the down-to-earth physical presence of the subject and the obvious artifice of surroundings sometimes produced portraits of astonishing charm.

While any portrait can be said to affirm status, studio images seem particularly designed for this purpose. The initiative lies with the subject who comes to the photographer's work space. The photographer creates an image that is detached from context and surroundings, part of a "transfigured" world. Some studios even provided fashionable clothing for the sitter.

Estelle Jussim, who saw the camera as agent for social change, writes about an immigrant studio photographer (her father) in New York City during the 1920s:

> What is important to our understanding of his career is the fact that Boris Ossypovich never not once, took a single picture of the human misery surrounding him, except for those brief moments when he was called into the tenements for deathbed memorials . . . it was as if he made no connection between the magic power of the camera to record his surroundings and those surroundings themselves. Photography had become little more than a business, a craft at which he had some talent, but he never seemed to connect that talent with the amelioration of social wrongs. . . .Trapped by domestic responsibilities and a trade that demanded all of his time, he made the best of it by refusing to see any implications of the camera. His metier was the portrait, his love was for the play of light to model flesh and cloth, and the drama of the posing, and it was as if he refused to see the people around him as part of any vast sociological phenomenon. He saw people as they wished to be seen, as unique individuals who had somehow reconstructed a life in a new country. He saw them as he undoubtedly saw himself, not in the real world, but in a world transfigured by an immigrant's dreams.[12]

Not only does Jussim get at the nature of studio photography but she also emphasizes the role of photography among America's huge immigrant population.

Unless the message is written in a foreign language, there's no certainty that the "real photo" subject is a first-generation American. Yet immigrant presence is a reality embedded in many postcards. Europeans came to this country in record numbers from 1870 to 1920, with immi-

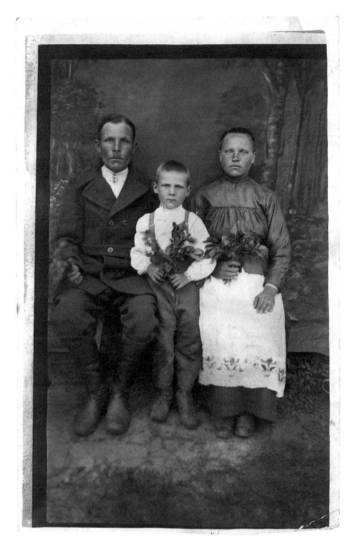

Immigrant family.

¶ How serious this young family looks as it sits for the camera, bouquets of greenery in hands.

gration peaking at 8.8 million during the new century's first decade.[13] These new Americans were eager to assimilate and to become part of their adopted nation. A portrait was a fine way to proclaim and fix this new American identity and status.

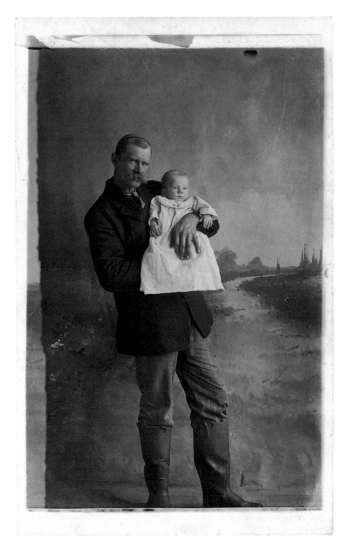

Father and child. Original photo by Fred L. Yagear,
Panama Rocks, Photo Artist, Panama, New York. 1907–1910.
"Extra copies— 50 cts. per doz. Order by No."

¶ This is an image laced with incongruity, incongruity of strapping man and tiny child so tenderly held, and of their physicality against the painted romantic landscape. The careful pose, neatly combed hair, and formality of coat and tie seem at odds with the backdrop's exposed edge and the man's work boots planted on painted road or river. We know what he's looking at so intently and the baby is not: the camera. We are struck with the man's concentration on the task: hold the child carefully, face the lens so that a fitting image can be made.

Aunt Bertha. People's Studio
"Tis a thirty minute picture," Roanoke, Virginia. 1923.

¶ Aunt Bertha shows us the power of the "real photo" vernacular, as presented by the "People's Studio." One solid chair, a good light, and a good subject are all this photographer needs. The People's Studio was most likely a studio for black clientele. In contrast to popular postcards which so often stereotyped and ridiculed Blacks, this image conveys respect for its subject.

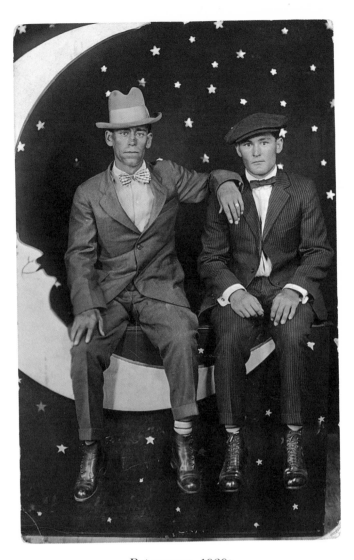

Paper moon. 1920s.

¶ For several decades a popular portrait prop, the paper moon varies in personality from studio to studio as do the human subjects that sit in its crescent.

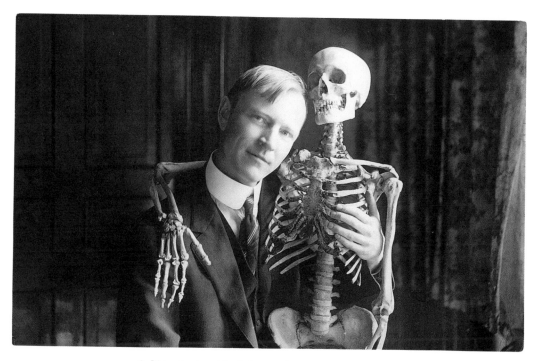

Self portrait with skeleton. Orson W. Peck photos,
Traverse City, Michigan. 1907–1912. Courtesy of Rodger Kingston.

"The girls in T.C. are so particular that I had to come to this. Orson."

PORTRAITS IN SITU

Many rural or small-town portraits, most unmarked, were made by itinerant photographers. Edward Weston (1886–1958) was such an itinerant working in California around 1906, although little of his very early work survives. His biographer, Ben Maddow, describes this period:

> He saved a little cash and bought a postcard camera, a predecessor of the Polaroid. The film was reversible, and one waited five to ten minutes before giving the customer, in exchange for a quarter, a nice moist print. Event and photograph were thus close together in time, but in time, the photograph (being insufficiently washed) faded into brown pale memory.
>
> With this sort of camera, Edward Weston walked or went on horseback from house to house, photographing dogs, cats, horses, and people. There

Child postmortem. 1910.

were three kinds of laboring foreigners in California at the time . . . all at the bottom of the economic pile: Chinese, Japanese, and Mexicans . . . Weston often photographed, for a fee, of course, the dark dead baby in its white dress laid out in a white coffin.[14]

Probably using a portable "postcard machine" that sacrificed quality for easy and speedy production, Weston developed his prints on the spot, and quickly. Maddow alludes to several elements prevalent in "real photo" postcards: Some are indeed "faded into brown pale memory," because they were not properly fixed or sufficiently rinsed in the developing process. It is disappointing to attempt to decipher such an image which no longer carries the strength of its real moment in the past. The "dead baby" refers to the Victorian practice that continued into this century—particularly in rural areas and among some immigrant populations (as referred to earlier by Jussim)—of postmortem photographs to help preserve memory of the deceased. Such images, which first appeared in daguerreotypes, appear occasionally in photographic postcards. As to his clientele, one finds many

examples that show subjects Weston might have photographed, immigrants and others "at the bottom of the economic pile."

In 1939 Weston recalls this early work:

> Jobs were infrequent, money needed, so I turned to my camera and canvassed house to house in the little village of Tropico, making postcards for a dollar a dozen—family groups on the porch, children, pets. I was still in my teens and had not yet decided on a career.[15]

A collection of glass plates made by the Howes Brothers, who worked as itinerants in western Massachusetts from 1886 to 1906, shows a remarkable cross section of group and family portraiture.[16] The brothers spent all but the winter months on the road, actively soliciting business at homes, schools, farms, and factories throughout western Massachusetts, even traveling as far afield as Rhode Island, New Hampshire, Vermont, and New York. The working-class people captured in their photographs would probably not have shown up in a studio, but these itinerant picture-takers made the process accessible and spontaneous. Although the images taken by the Howes do not exist in postcard form, their account reminds us that these photographers, like those who made "real photos," were in business to make a living. Like Weston in his early days, they took their clientele as they found it. The gravity, candor, and self-conscious naturalness of their subjects are absolutely kindred to countless postcard images which, like those made by the Howes, show people "in the midst of their settings and undertakings."[17]

Is there an itinerant aesthetic? In postcard portraits similar to images Weston or the Howes brothers may have made, one sees a subject who looks directly at us. Usually outdoors for natural light, he, she, or they stand in best clothes against a clapboard exterior wall, on a porch or sometimes before a pinned-up blanket or sheet that serves as backdrop. Or the subject may pose away from the house, on the grass, in the garden, on a swing, or beneath some trees. The focus is on the person or people being photographed. Extraneous details like clutter or broken floorboards or a turned-up rug are unimportant, although we notice them now. These are remarkably direct images: the subject may be posed or self-conscious but is usually seen in his or her context, and there is little effort to glorify or embellish as one frequently finds in studio portraits.

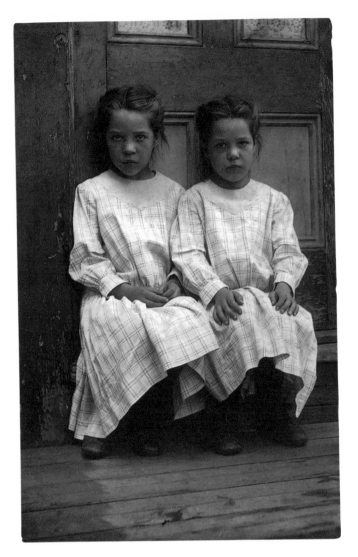

Twins. 1910–1918.

Walter Benjamin attributes much of the power of the daguerreotype to natural light and lengthy exposure times, saying of its subjects, "during the long exposures they grew, as it were, into the image."[18] One senses that some "real photo" subjects grew into the image as well.

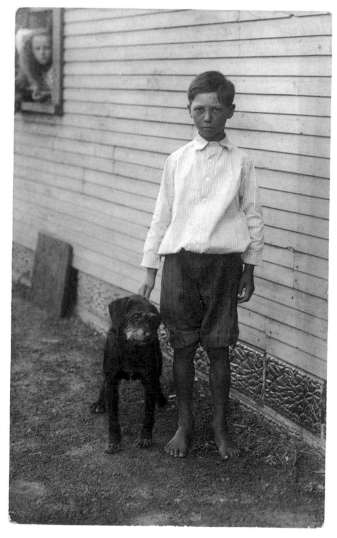

1910—1918.

¶ The somber barefoot boy and wistful dog hold our gaze, but the picture is animated by the relentless diagonals of receding clapboard wall, by the board that leans against it and echoes the rectangular window above, by the unfocused curious face in the window, and the surprising shiny texture of the foundation wall.

109

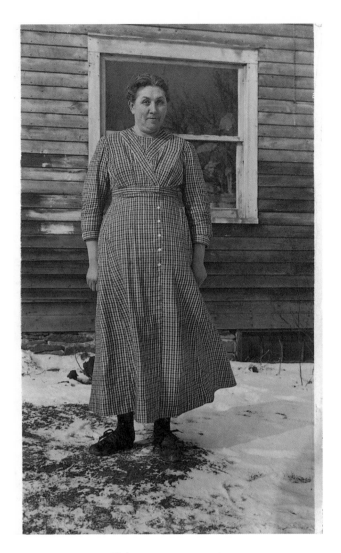

Rebecca. 1910–1917.

¶ This is such a stable picture, all verticals and horizontals except for the collar and windswept skirt. Rebecca, her left foot solidly at center, is a pillar of cheerful strength.

¶ *(facing page, bottom)* Four wriggly children and a new baby—not an easy group to photograph. Only the boy seems to appreciate the gravity of the moment as he places one hand upon the dark heap cradling the infant and looks intently at the camera. The girls seem perched to tilt right out of their rockers. In spite of the spectacle of these delicious children, our eye drops to the disconcerting hole in the floor beneath the baby. That hole gives an edge to the picture and reminds us of life's flaws and unknowns. Bows and little girls' lockets could get lost there.

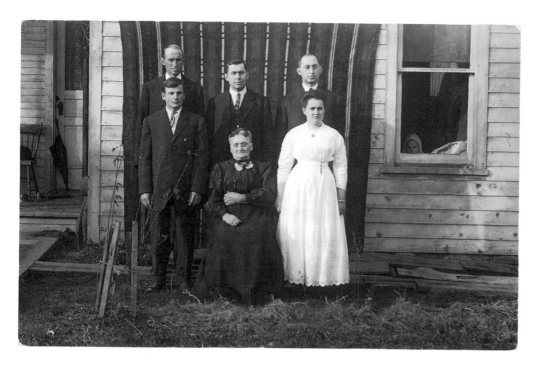

McClure, Pennsylvania. 1910–1918.

¶ The family matriarch sits enthroned and the next generation peeks from the window.

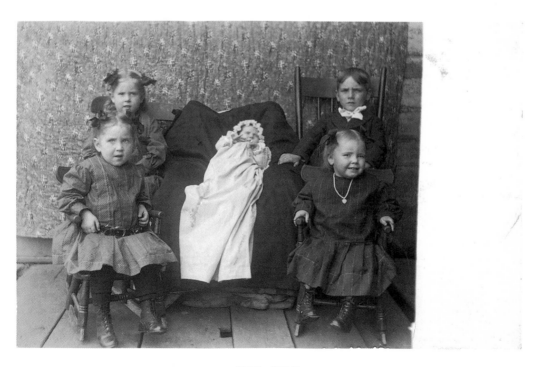

1910–1918.

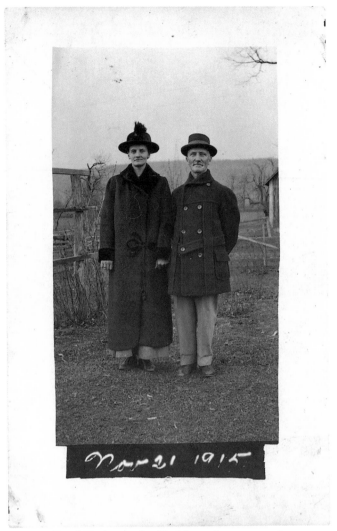

Boyd Kocher and wife. November 21, 1915.

¶ An autographic camera allows the photographer to record the date of this picture. The Kochers, dressed in their Sunday best, stand at attention for their portrait. Their heads cut across the horizon line, accentuating the land behind them, as if to confirm their status as new Americans and landowners.

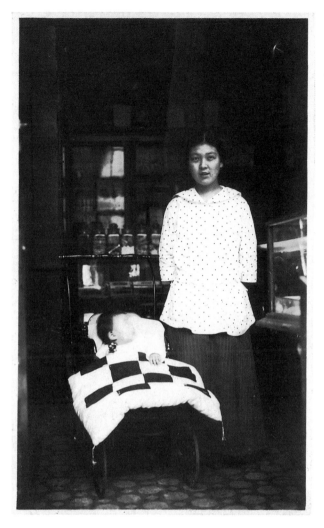

Seattle, Washington. 1910–1918.

Immigrants came from the Pacific Rim as well as from Europe, with Asian immigration peaking from 1900 to 1910. Seattle was a major port of entry for the Japanese. While postcards did not seem to be within their repertory as pictorialist photographers, Japanese-Americans founded and constituted most of the membership of the Seattle Camera Club during the 1920s.

One Japanese-American photographer did make postcards. Frank Matsura was a Japanese immigrant who arrived in Seattle in 1901. He moved to the small town of Okanogan in eastern Washington where he opened

113

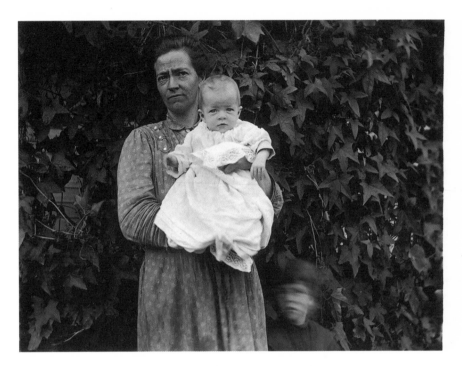

1912–1915.

¶ She holds her baby before a wall of ivy. The boy at her side moves his head, reminding us of that fleeting moment that the camera captured, and in the case of the boy's portrait, captured imperfectly. The camera, however, caught his motion perfectly. This mother, with her worried look, commands our attention, and we see in the baby's features the continuity of generations. Her buttons, the lacy edge of the baby's wrapping, her fatigue, the boy's movement—all real.

a photography studio in 1907. There, he recorded townspeople and frontier life with hundreds of images that he made up into photographic postcards from 1907 until his death in 1913.[19]

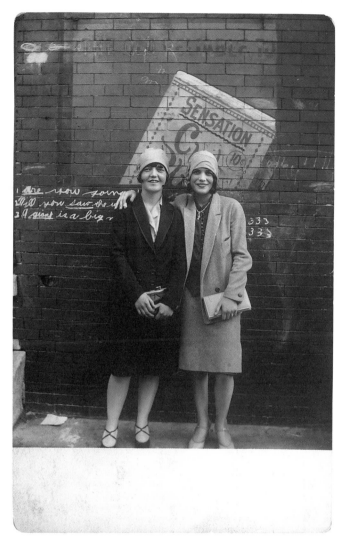

Philadelphia. Photo by John Frank Keith. 1920s.
Courtesy of Rodger Kingston.

¶ John Frank Keith (1883–1947) was an amateur photographer who photographed working class families and friends in his Kensington, Philadelphia neighborhood during the 1920s. Urban sidewalks and stoops were the usual settings for his postcard portraits of striking freshness and intimacy. Here he captures two young women who pose happily before a brick wall enlivened by graffiti and the oddly askew "Sensation" sign.

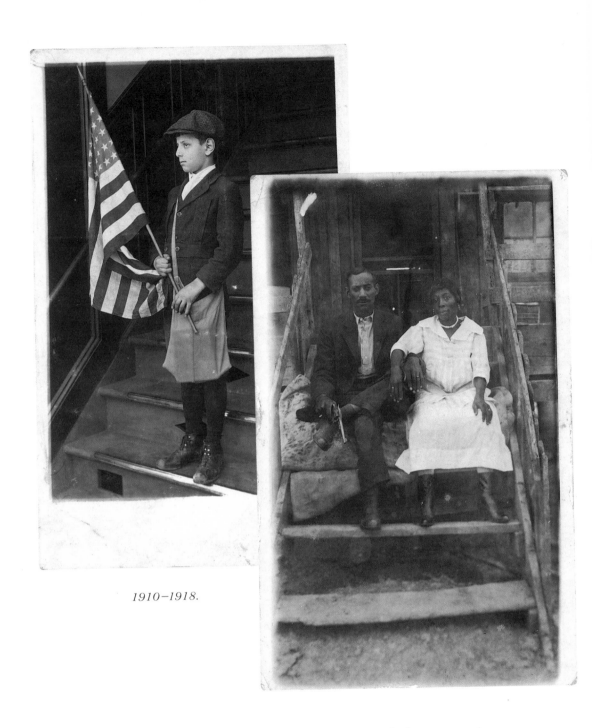

1910–1918.

¶ The boy with book bag and American flag; the couple, her arm resting so easily on his, a revolver held so easily in his hand—Americans photographed on steps, each with expectations for the new century and each holding symbols still loaded with meaning today.

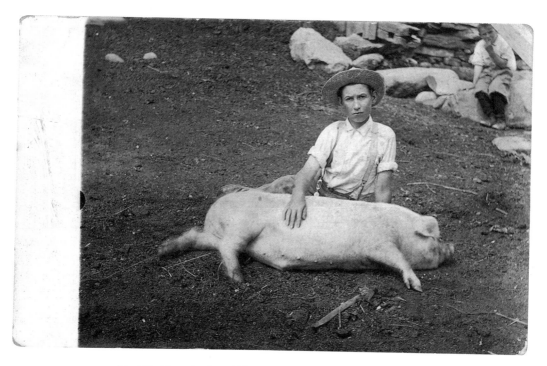

Bert E. Cunningham Photographer, Liberty, Maine. 1923.

"Dear Aunt—Hear are two pigs. Joe wants to know if you know which one is he. Find Arthur in the corner. Rena."

¶ An image of rural America, and a succinct message here: the author's humor and Joe's affection for his pig. The boy studies the photographer and trusts him to get it right. He does.

FOR TOURIST CONSUMPTION

An exception to the kinds of portraiture we have seen thus far is that of native populations made for the tourist market. While mechanically printed cards served most of that market, "real photos" were also a factor. Such postcards were not made for the subjects or their families, but were made of them, for consumption by a majority population who viewed people of color as primitive, inferior, and, in the case of Native Americans or some of their foreign equivalents, as an exotic, disappearing people.

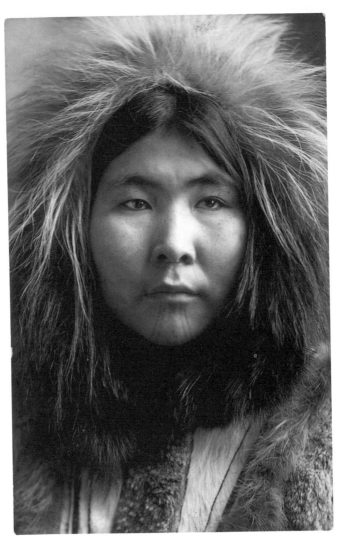

Alaskan woman. 1910–1918.

¶ This and the next image speak to the fascination indigenous peoples held for Caucasians. Anthropology was of growing interest, Native American crafts and artifacts were avidly collected, tourism to "primitive" sites was expanding, and native populations and cultures were popular subjects at world expositions, as well as in Western art and academia.

The intense close-up is uncommon. We almost share this woman's physical space. Yet her gaze—not at us but beyond us—keeps us at a distance, permitting us to look at her while she maintains her dignity. There is strength and tremendous presence in this portrait by an unknown photographer.

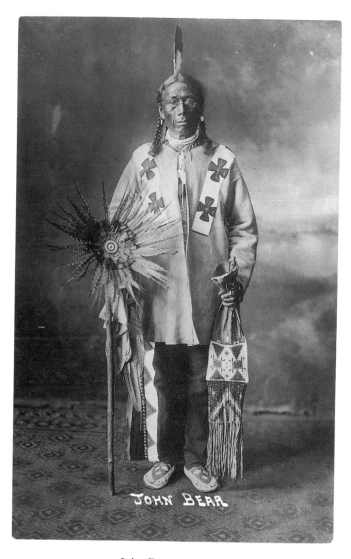

John Bear. ca. 1910.

¶ In full regalia, this proud Sioux Indian stands for his studio portrait.

Subject and viewer: a relationship always at the heart of the portrait image. Who were these postcard images for? Was the person photographed actively involved in the end result, or closer to object whose image was requested by family members, perhaps? Or even, for others, an object of curiosity? Barthes, too, confronts this complex question:

The portrait photograph is a closed field of forces. Four image-repertoires intersect here, oppose and distort each other. In front of the lens, I am at the same time: the one I think I am, the one I want others to think I am, the one the photographer thinks I am, and the one he makes use of to exhibit his art.[20]

Always sendable, was the card—aside from those made for the tourist market—intended for a distant friend or relative? Or was the photo postcard just a useful and cost-effective commodity, a form of portrait imagery promoted by the photographer, appealing, self-confirming, and practical for the client-subject? It seems likely it was all these things. The "real photo" postcard portrait met a social need and offered a very personal kind of communication in an increasingly mobile society. Affordability and availability made possible by Kodak and others encouraged its popularity, as did the enterprise of the individual photographer who sought out his subjects.

"Real photos"—particularly when newcomers were entering the country in record numbers—are a continuation of the nineteenth-century portrait tradition described as a "new way of seeing themselves in the eyes of others, seeing oneself as an image . . . A new form of social identity."[21] They follow a heritage of daguerreotypes, *cartes de visite*, cabinet cards, tintypes, and photos in presentation folders. Within this tradition, photographic postcards are the tough little humble cousins, akin to the tintype: unmounted, unprotected, hand-produced by local or visiting photographers, unpretentious, on home ground, cheap, and ready for mailing.[22]

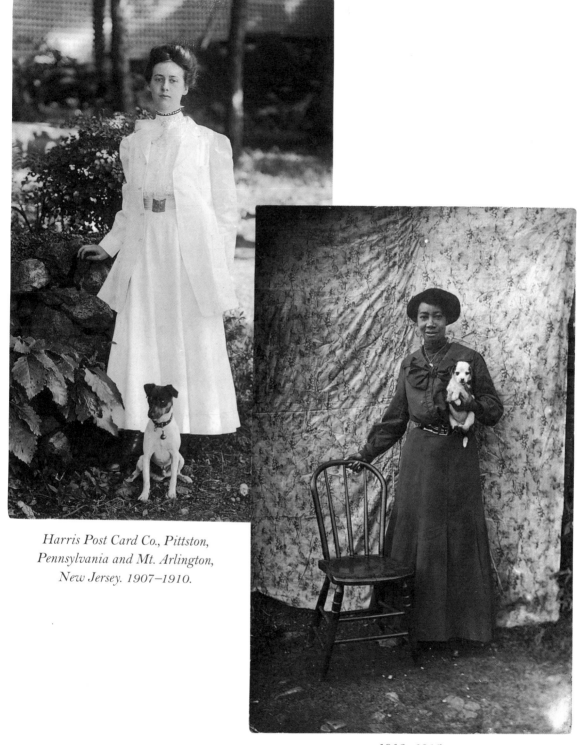

Harris Post Card Co., Pittston, Pennsylvania and Mt. Arlington, New Jersey. 1907–1910.

1912–1915.

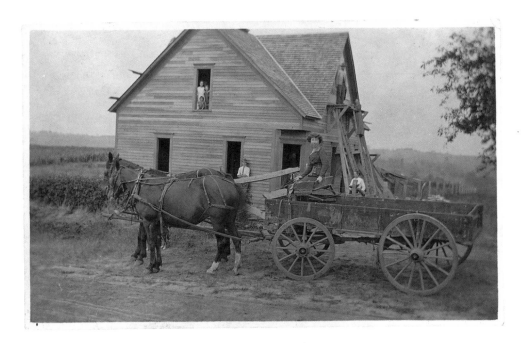

Missouri. 1913.

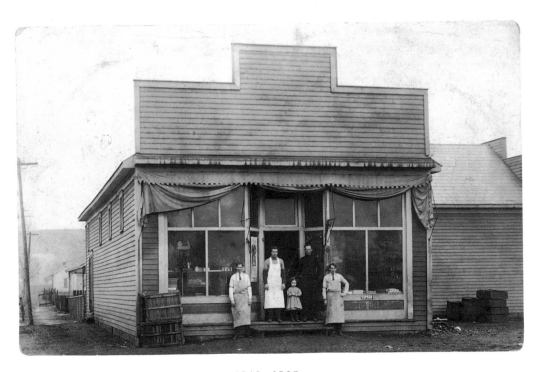

1910—1918.

BUILDINGS: HOME AND WORKPLACE

"REAL PHOTO" portraits were not only of people. Architecture of all kinds was photographed, much within the repertory of view photographers, who recorded buildings significant to the local community. Other postcard images were commissioned or made by proud owners in towns and rural settings. Buildings were photographed because they were people's homes or workplaces. While the buildings are the ostensible subjects, it is the people who own or live in them or the work that occurs there that are important. The photograph conferred status and, for business owners, promoted their enterprise.

These portraits often include people and possessions: a car, a bicycle, a pet, livestock, family members, or workers. Through such photographs, one learns about vernacular architecture and settings in different regions of the country. One notices architectural details and materials, windows, awnings, doorways, porches; yards, plantings, outbuildings, sidewalks; signage and commercial displays. One gets a sense of everyday life and a better understanding of the people who inhabit these buildings.

It is perhaps appropriate here to speak again of Eugène Atget (1857–1927), the French photographer whose images made from glass plates offer a remarkable sense of place.[23] Atget was working in Paris at precisely the time that photographic postcards were being made. Hailed as a model for modernist photography, Atget seems an odd bedfellow for "real photo" makers. Yet, in some important respects his approach was similar: he recorded what he saw and let the subjects speak for themselves. And he evoked a sense of loss for what was gone. More oblique, far less populated, and more poetic than America's frontal "real photos," his record of *Vieux Paris* is elegiac without being sentimental. But in diametrical opposition

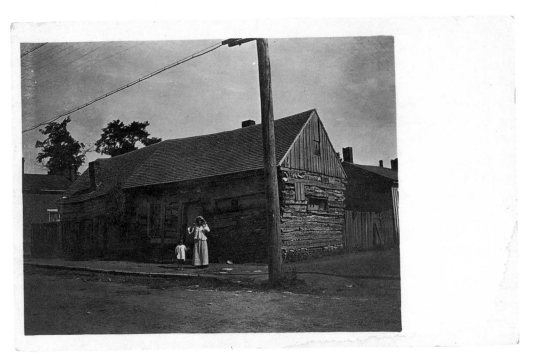

1905–1906.

¶ An electric line reminds us that this is the twentieth century. This is a portrait of America's "other," its black ex-slaves. The image reflects a key part of American identity: the legacy of slavery and the nation's uneasy relationship with its black population. Although Blacks were beginning to move North, the great migration to northern cities would not come until the next decade when four hundred thousand Blacks left the South between 1916–1919.

to "real photos," Atget recorded a disappearing past. The postcard photographer recorded and expressed the new America, a nation in formation looking to the future. Although we now see our past reflected in "real photos," this is a crucial difference.

HOME

Of all the subjects of "real photo" postcards, homes are among the most personal. These photos frequently include family members; they represent nurture and welcome; they are objects of pride, close to the heart. When elderly family members are shown, they honor the past. With the young, they look toward the future. "Homestead" had meaning: the Homestead Act remained strong in the West until 1925.

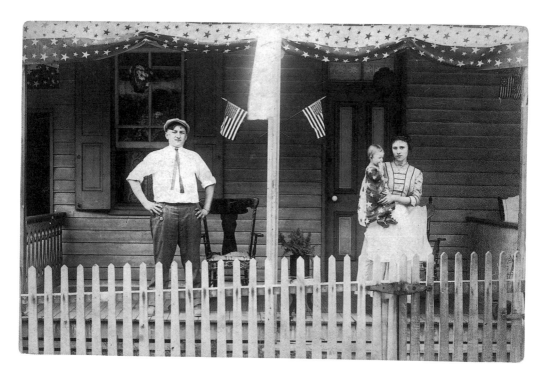

ca. 1907.

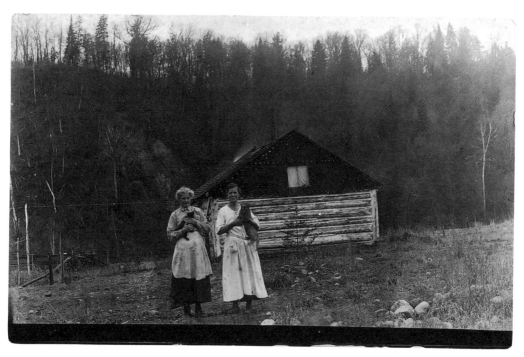

Cats help make a rural home. 1918–1920s.

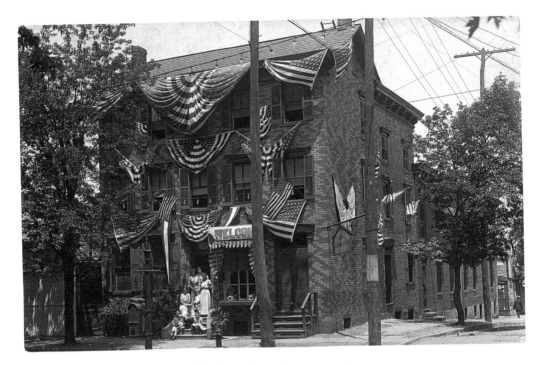

A welcome home. 1910–1918.

¶ Perhaps the bunting welcomes a soldier returning home from World War I. Utility poles, wires, mailbox, and electric bulbs further announce the changing twentieth-century world.

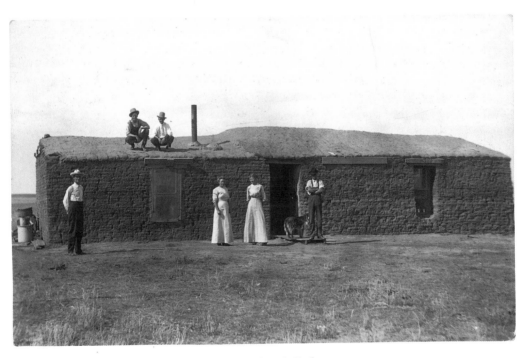

Sod house. Northwestern South Dakota. 1910–1918.

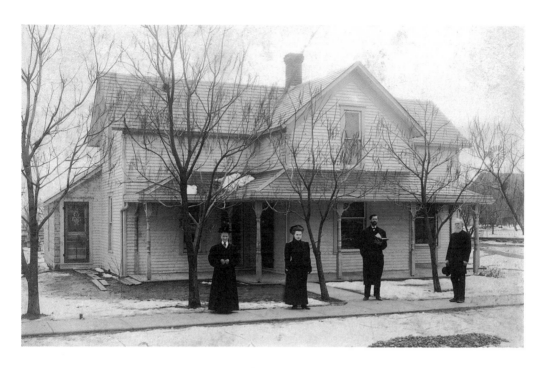

Indiana. 1909.

"Friends we are well and by turning this over you may immagen how we appear at our residence in copany of our pastor Rev Mullican & our grand daughter Minnie Abbot Arthur bought a grocery at Phiffton Edgar clerk for him we have a mild winter our legeslature supported local option by Counties and it works like a charm Glory to God From D W Abbott."

¶ The vertical array of dark-clad figures, bare tree silhouettes, and porch posts; the message's interweaving of secular and religious content; the play of lights and darks—all these give this card great visual appeal and power. It articulates still cherished values of local autonomy and anticipates the ongoing national effort to balance church and state. In this portrait, home is where God is. And county governance matters.

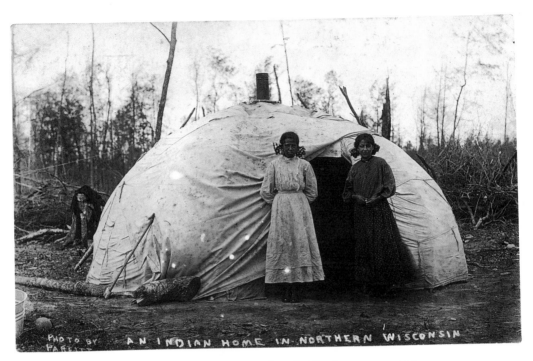

Northern Wisconsin. Photo by Parfitt. 1918–1920s.

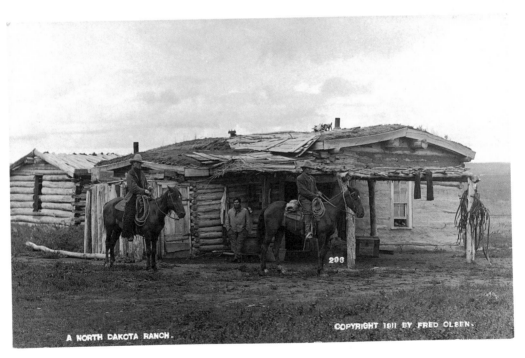

North Dakota ranch. Fred Olsen photo. 1911.

1910–1918.

"Shorty Weidner this is our barn. S Tinicle."

¶ A farm is home and workplace. Built into a hillside or ramped, this barn offered easy access to two levels, with lower level housing livestock. In this symmetrical barn portrait, the cat marks the door's center and stands between the two generations pictured.

WORKPLACE

The workplace could be the family farm, a small business or production site, or a large enterprise, such as a mill or a factory. Storefronts across the country reveal commercial enterprise and the necessities and amenities of urban and rural life.

1911.

"The Picture on the other side is of my Factory. Your Uncle Frank."

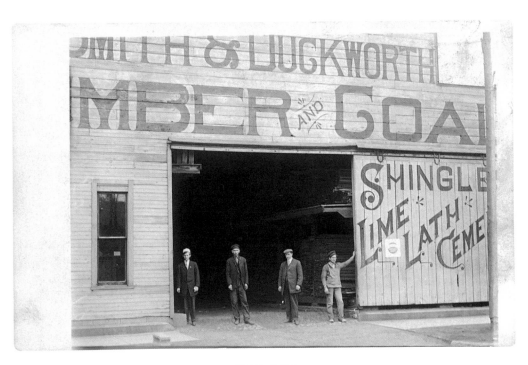

1907–1912.

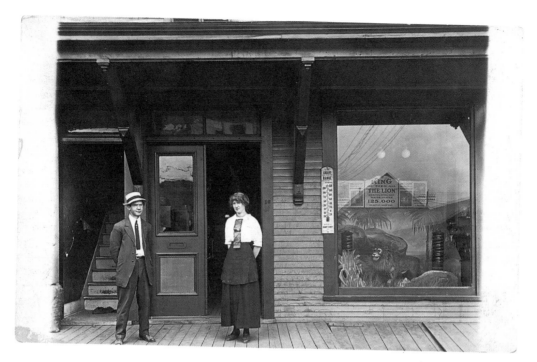

1910–1918.

¶ The Lion display window is an essential part of this store portrait.

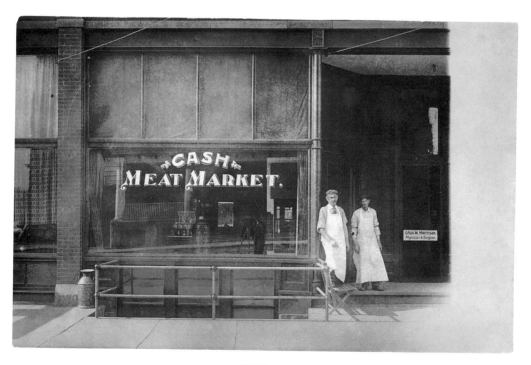

1907.

¶ Look closely at the store window where interior display items vie with reflections of columns and railings from across the street and photographer at work with camera on tripod.

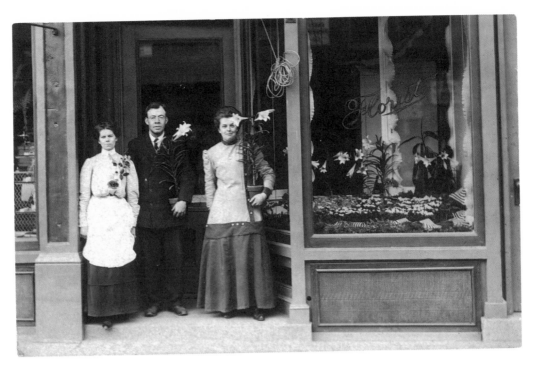

"Mr. Brigham's store." 1907–1912.

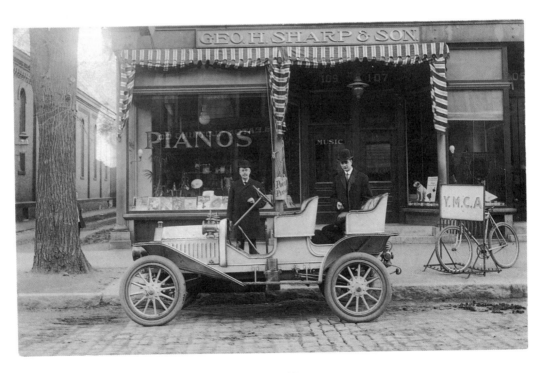

1909–1912.

¶ Owners and automobile are front and center in this store portrait.

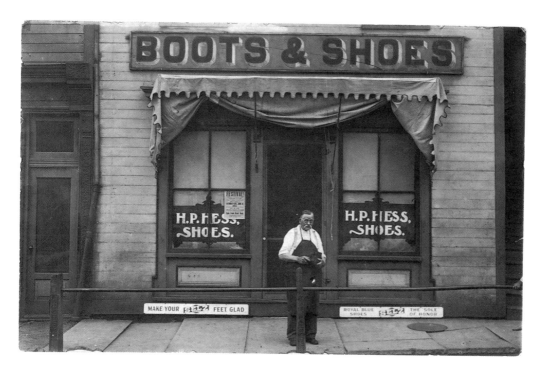

Ohio. 1911.

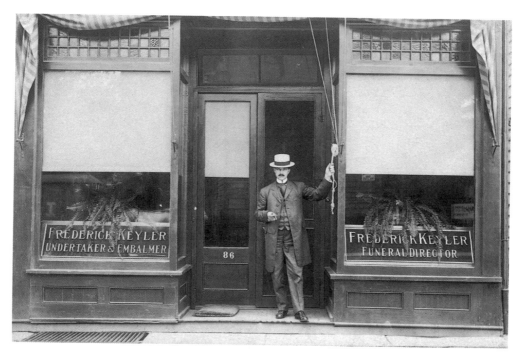

1907—1920.

"Everything lovely here. Weather is grand with best regards to all.
Frederick Keyler."

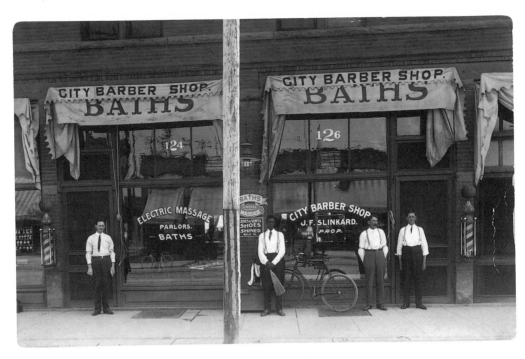

Grand Junction, Colorado. 1912.

"Dear Father and Mother, I feel like I have lost the only friend that I had
in this wourd. I can't hardly go to my home any more. Goodbye. Love to all.
J. F. Slinkard."

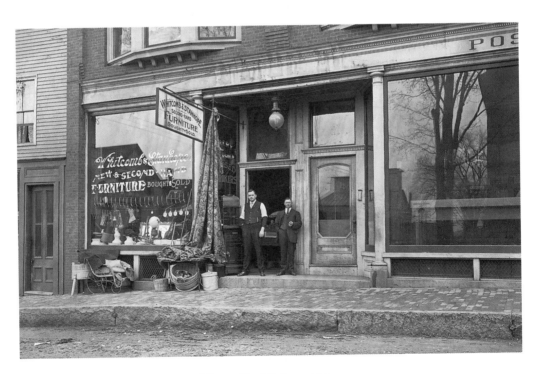

Waterville, Maine. 1909.

"...with best of regards, from Whitcomb & Stanhope, No 50 Centrall St."

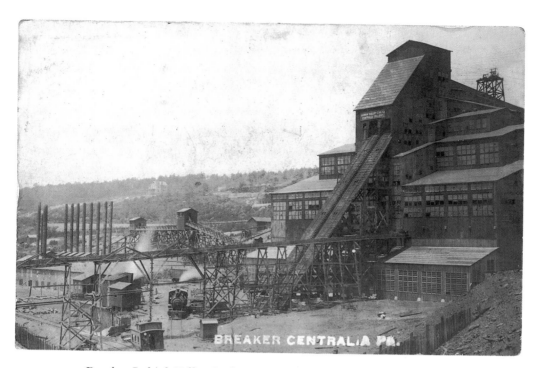

Breaker, Lehigh Valley Coal Company. Centralia, Pennsylvania.
Photo by J. K. Baum, Middletown, Pennsylvania. 1908.

"This is one of John's breakers where coal is broken into different sizes after it is brought out of the mines."

¶ The railroad engine helps us grasp this breaker's mighty scale.

Chesapeake Pulp and Paper Mill. West Point, Virginia. Photo by Barker. 1914.

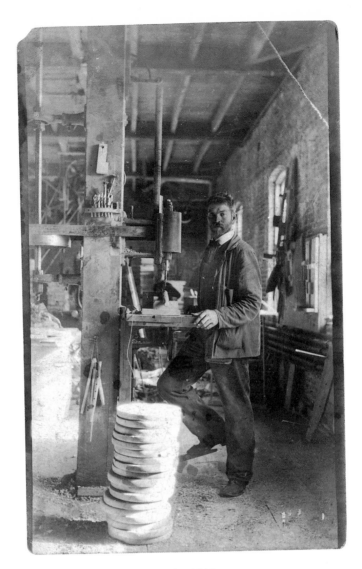

1907–1910.

"Dear Sister & all . . . you wanted to know about the squashes they are a cent a lb do you want them sent by freight or express & he has some awful large ones wishing you all a happy Thanksgiving and Xmas. Can't you try & come. Yonak."

¶ As if interrupted, a man pauses at the drill press, one foot on the treadle, and looks toward the photographer. The drama and reality of receding space, the dignity of the standing figure at work, and the picture's lively surface detail all contribute to the power of this image. Perhaps Yonak is the man in the picture.

[CHAPTER ELEVEN]

AT WORK

ANOTHER popular category of photo cards is work itself. "Real photo" work scenes are usually posed and static. Frequently, workers line up inside or outside the shop, or they face or turn away from the camera with worktable and tools displayed. Often, the photograph simply records the work environment: barrels at a cooperage, the field or quarry, the factory floor. One seldom sees people doing work, and this may be related to the photographer's concern with movement and focus. But I believe there is more to it than that. The posed self-consciousness of such photographs occurs because of the camera, because these are portraits. These were personal images, intended for someone, and they were important. The camera's moment was a moment to attend to, and these subjects certainly did.

To me, some of these images represent the best of "real photo" production. The photographers who made these pictures were probably professionals, from small-town studios or working as itinerants. We know little about their experience or exposure to other visual work, whether painting or photography, or whether any direct influences exist. We do know of two masters who worked at least briefly as small-town itinerants, Clarence White between 1904 and 1906 and Edward Weston around 1906.[24] There was, as well, an emerging American documentary tradition —exemplified by Lewis Hine whose child labor series (1907 to 1917) was published during the height of the "real photo" era and whose work focused on the individual worker and his or her working conditions. Some of the most compelling of these postcard images, like those in the social documentary mode, convey the photographer's sympathy with his subject.

Occupations old and new, indoor and outdoor, and businesses large and small appeared in "real photo" cards. Some images speak of a growing nation, industry, commerce, communications, new technologies, and a

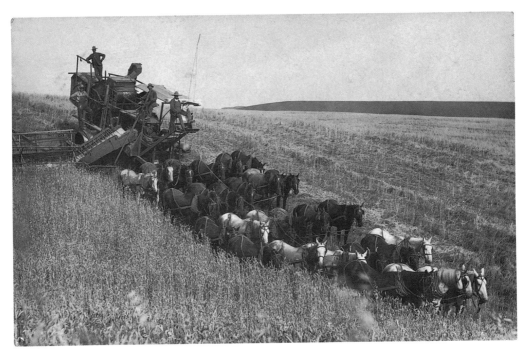

Harvesting near Colfax, Washington. 1910.

changing landscape. Others show traditional handcrafts and business ventures.

America was changing but was still agrarian. In 1900, 60.3 percent of the nation was rural. By 1910, that number had declined to 54.3 percent, with land devoted to harvested crops peaking in 1919.[25] Soon the balance would shift, so that by the early 1920s, urban population would be greater than the rural. But for much of the period covered by "real photo" images, agriculture and agricultural workers were still dominant in American society.

Farm production involved people, animals, and machines. Steam-powered farm equipment was introduced soon after the Civil War and, before long, would be replaced by gasoline-fueled. The photographs that follow speak of transition: from men, mules and oxen to mechanization and, as we can see so clearly now, from a predominantly rural to an urban society.

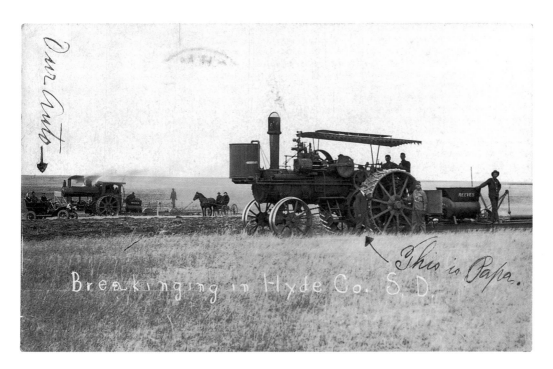

Hyde County, South Dakota.
Photo by H. A. Syverud, Highmore, South Dakota. 1909.

"Dear Frank . . . As you know, we have about 600 qts. of gooseberries this year.
We have been picking for over 2 weeks and haven't gotten thru yet. . . ."

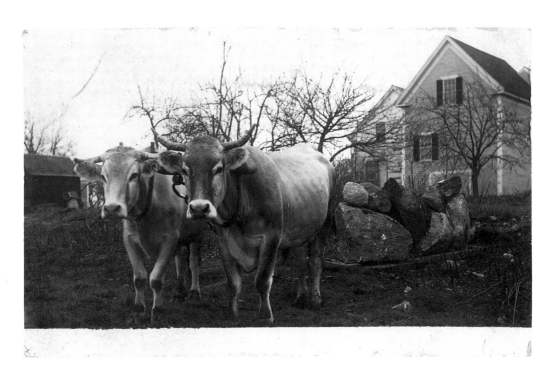

New England. 1907–1912.

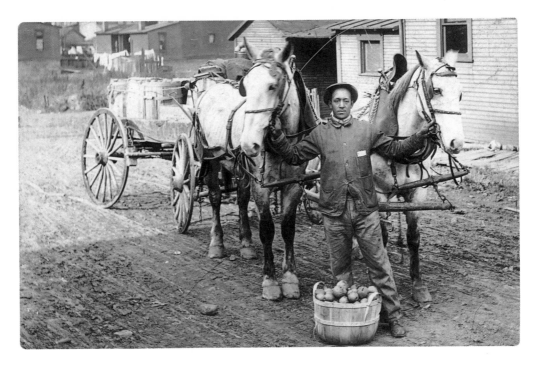

Will Thompson. Brownsville, Pennsylvania. 1910–1918.

"I am send you my Papa's picture selling pears in Brownsville.
Wishing you a pleasant Xmas, Jean Thompson."

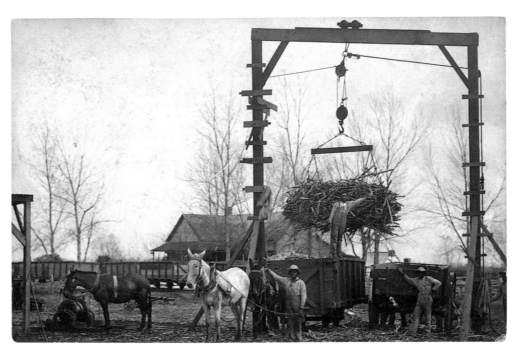

Loading sugarcane on to rail cars. Sugar Land, Texas. 1907.

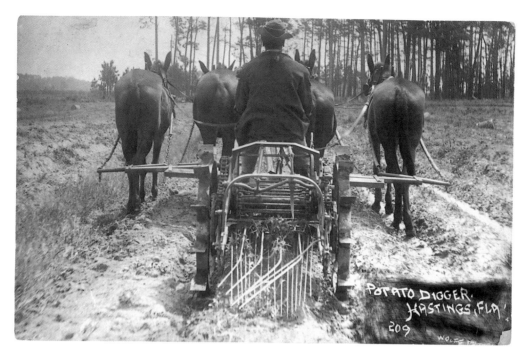

Potato digger. Hastings, Florida. Wolfe photo. 1910–1918.

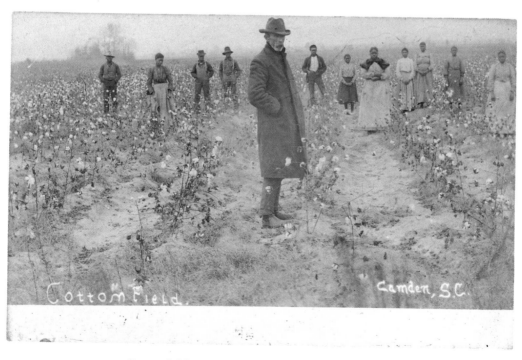

Cotton field. Camden, South Carolina. 1905–1906.

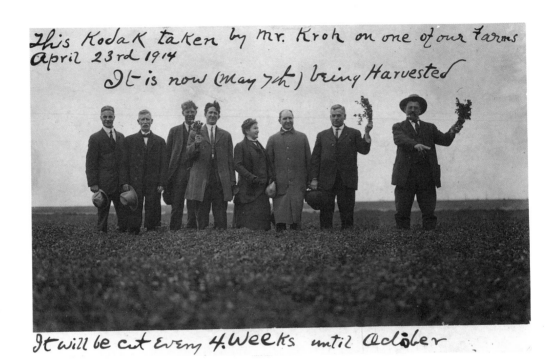

This Kodak taken by Mr. Kroh on one of our farms April 23rd 1914

It is now (May 7th) being Harvested

It will be cut Every 4. Weeks until October

Mr. Kroh's Kodak. Texas. April 23, 1914.

¶ A benign image, proclaiming owners' pride in farm productivity. But words on the reverse side reveal not only specifics of hay and alfalfa pricing and production but also more:

"We raise no coarse 'woody' alfalfa our quality is of the Finest. It cures in our climate Bright and fragrant. The great Cotton Plantations do not raise feed for Mules or Niggers—They consume our products."

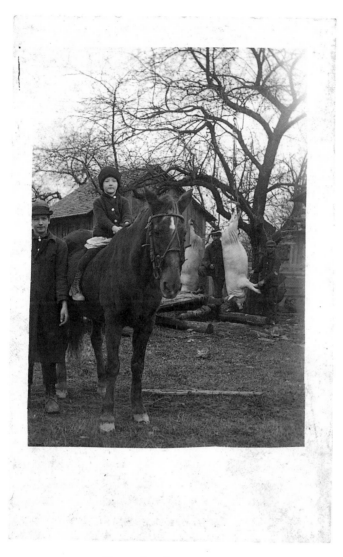

Pennsylvania. 1912–1915.

¶ Hogs hang in many "real photos" —their pork products an important part of the agricultural economy and rural self-sufficiency.

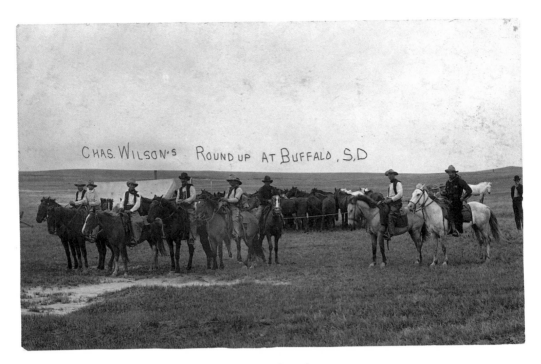

Roundup. Buffalo, South Dakota. 1907–1912.

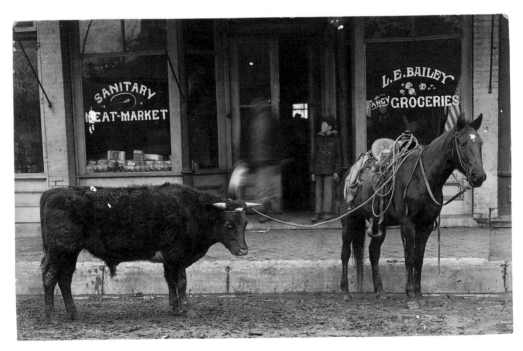

1910–1918.

¶ Steer and cow pony wait patiently outside the Sanitary Meat Market.

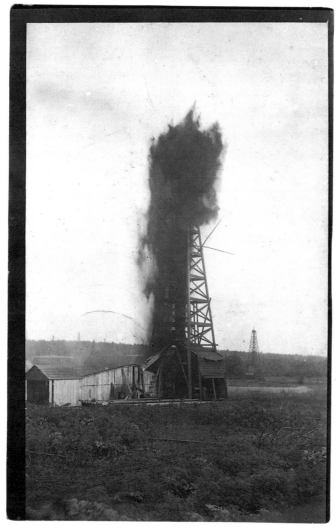

Oil well. Kiefer, Oklahoma. 1908.

"Dear Friend Earl. Here is a Postal of a flowing well and they very near all flow like it when they are just drilled in. So you can think the amount of oil they make. from John."

¶ Oklahoma's statehood, the forty-sixth, came in 1907, and oil was the prime commodity.

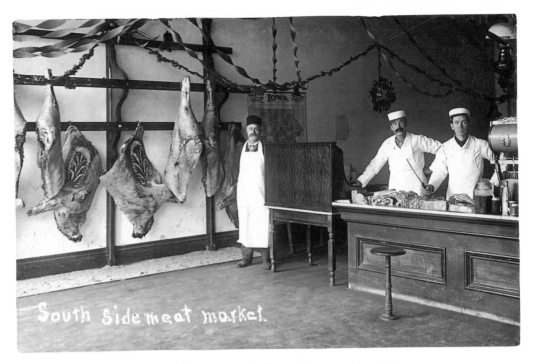

South side meat market. Keota, Iowa. 1907–1912.

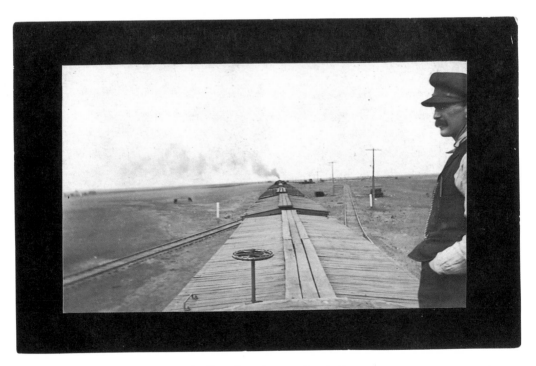

Railroad worker. 1907–1912.

¶ Telegraph lines accompany railroad tracks—evidence of communications and technology in a country of vast spaces and distances waiting to be filled and connected.

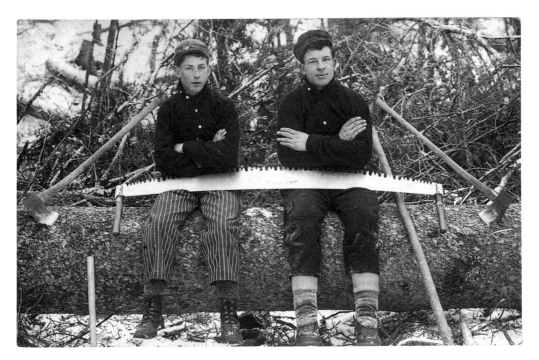

Loggers. 1910–1918.

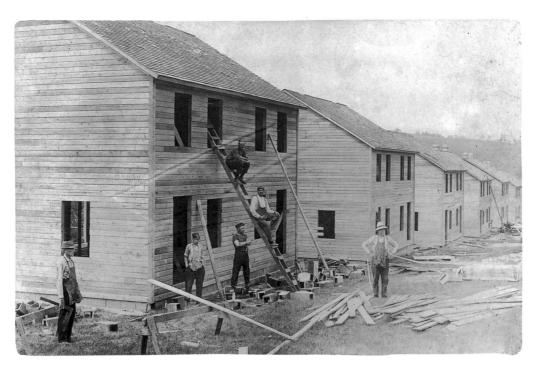

Freter Bros. "famous post cards," Bridgeport, Ohio. 1912–1915.

¶ The new world offered abundant timber for a nation under construction.

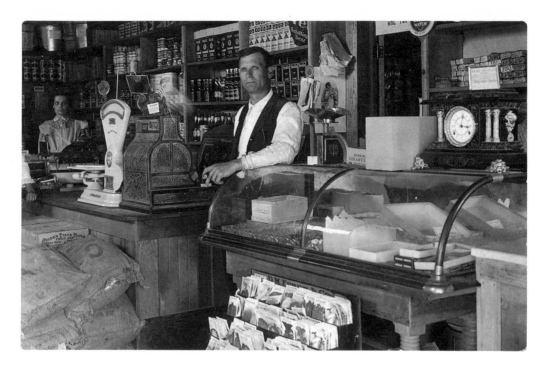

General store. Oregon. 1912.

"Dear Aunt, It is with Pleasure I answer your card. You wanted to know about my Father and Mother. They are living in Grants Pass, Ore. Father is very poorly, has been sick sometime. We are very uneasy about him. From Your Nephew, Frank Bailey. The picture on the other side is the grocery side of my store."

¶ We can't quite read the foreground seed packets, but nearly everything else is just as clear and clean as Frank's neat store, although the "ghost" of a small American flag flying above the cash register seems odd and otherworldly. We see Frank's lighted cigar, know that it's approximately 3 P.M., that he uses a Toledo scale, and sells tea, soda, canned goods, tacks, mason jars, and brew. Our eye even takes in the "Notice to Dealers" sign hung on the fancy cash register. This image is all about commodities and American enterprise, but it also tells us about Frank's status as store owner, his or his storekeeper's tidy management, and his customers' needs.

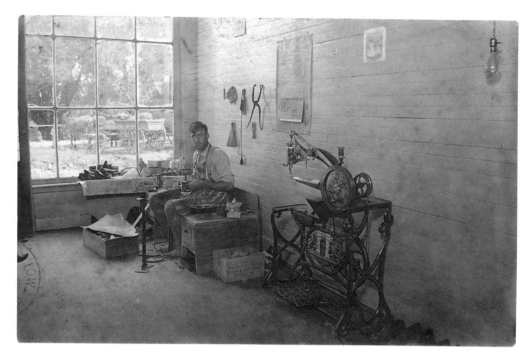

Shoemaker. Iowa. 1912.

"How is everybody. Received babe's clothes. Many thanks for the same.
I put them right on her as it was what she needed. She will be a year old
Friday. So-long — Maggie G."

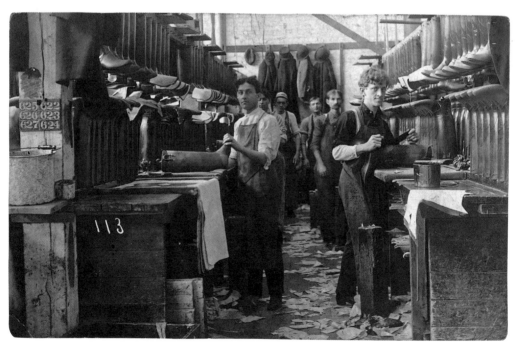

Bootmakers. Photo by C. F. Kaylor, Mishawaka, Indiana. 1907–1912.

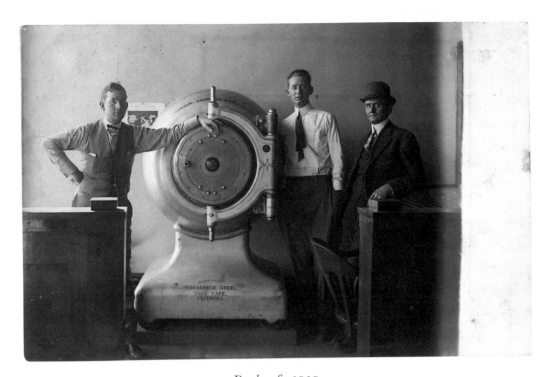

Bank safe. 1910.

". . . the bank Joe organized and built."

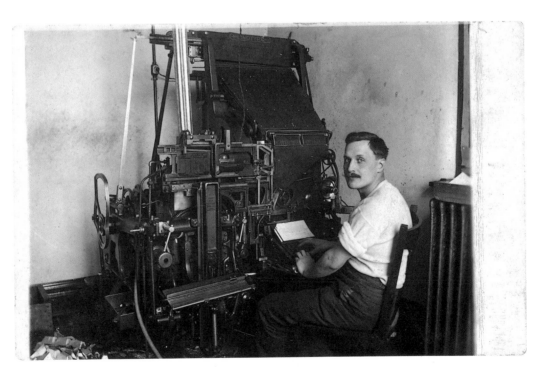

Linotype machine operator. 1912–1915.

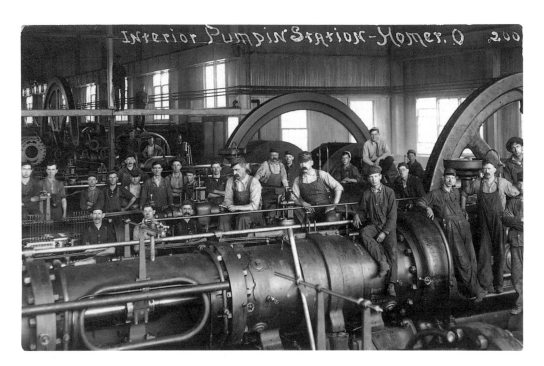

Interior pumping station. Homer, Ohio. 1910.

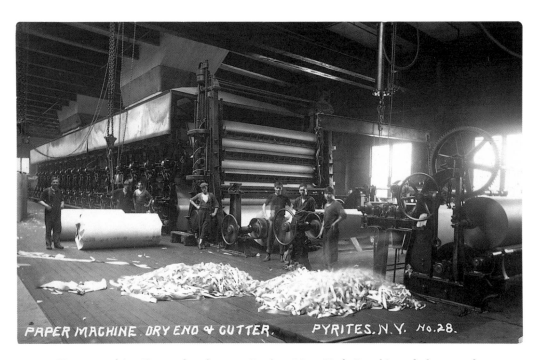

Paper machine. Dry end and cutter. Pyrites, New York. Beach's real photograph,
Remsen, New York. ca. 1914.

¶ Henry Beach produced hundreds of postcard images in northern New York
state and environs. Subjects ranged from military camps to work and resort
scenes.

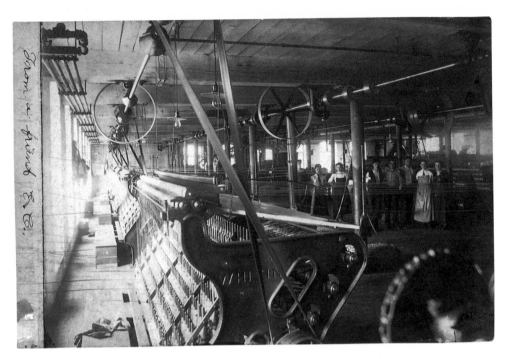

Textile mill. Rhode Island. 1905–1906.

"That is the best picture I can send you of the room. From a friend, E. C."

¶ One senses that the great Whitin looms are the stars of this weaving room. Four of the seven workers shown in the background are young women.

Women's work outside the home was limited. Teaching and nursing were traditional occupations. The telephone and typewriter introduced new opportunities, and mills and factories continued to employ numbers of young women.

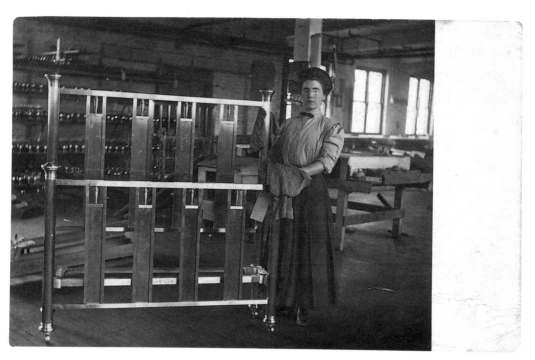

Edna Brandt, bed factory. 1907–1912.

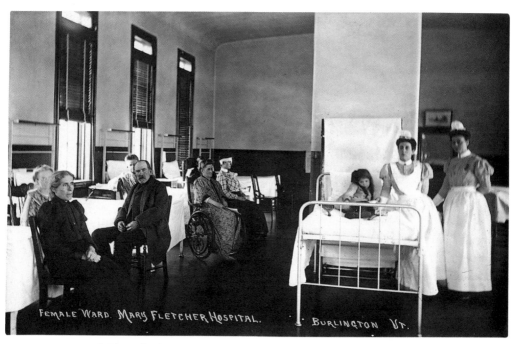

Mary Fletcher Hospital. Burlington, Vermont. 1910–1918.

Laundress. 1907–1912.

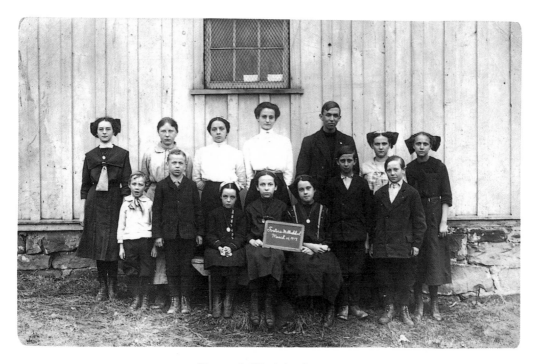

Fosters Mills School. 1914.

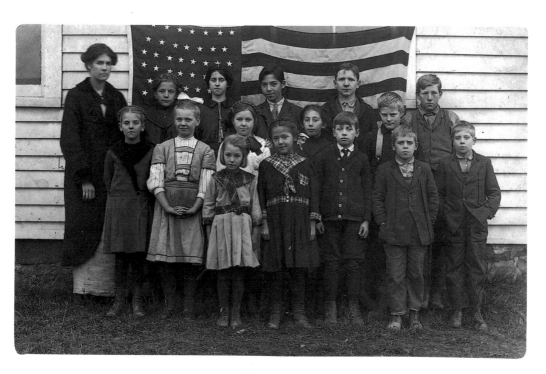

1906—1908.

Ohio. October 29, 1908.

"Pa & Ma, This big rock is in layers and full of pebbles all colors.
I never saw as pretty a rock it is stuck in the Hill as if some one
had just stuck it there. I done some climbing to get where I am
in the picture."

PLAY AND CELEBRATION

IF the camera recorded work in a deliberate and careful way, it also recorded play and celebration. Leisure afforded all sorts of photo opportunities for both professionals and amateurs. These photographs provided memories and revealed the diversity of American geography, entertainment, interests, and rituals. The impetus for the photograph varied. Some photos are resort views. Seemingly spontaneous—a scene on a lake, a group of people snowshoeing, a crowd gathered for a concert—they were made by professionals, carefully framed to show off the attributes of the resort area and sold in local shops and hotels. Other photographs, by both professionals and amateurs, recorded the pleasures of leisure and recreation, such as fairs and sporting events, or the spectacle of local celebrations and rituals. Some informal photographs clearly seem to be the work of amateurs, often slightly out of focus or with their attention directed to a group of friends or family members. We enjoy the subjects' amusement and pleasure and feel the spontaneity of their response.

1910–1918.

¶ A circus, an acrobat, a daredevil—traveling entertainers brought excitement to small towns and countryside where crowds turned out for the spectacle.

Heavyweight boxing champion Jess Willard with his manager.
Feldman Pictorial News Service, El Paso, Texas. 1915–1918.
Courtesy of Rodger Kingston.

¶ Willard held the world heavyweight title from 1915 until 1919 when he was defeated by challenger Jack Dempsey in a fight still considered to be one of the most brutal beatings in boxing history.

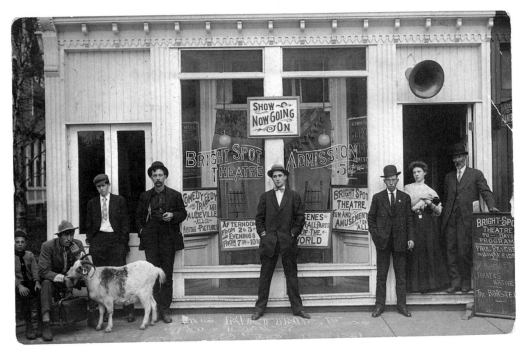

Bright Spot Theatre. Sidney, New York. Photo by C. H. Phelps. 1907–1914.

"Friend Mildred: I received your postals and will answer them.
Your sincere friend, Harvey Gardner."

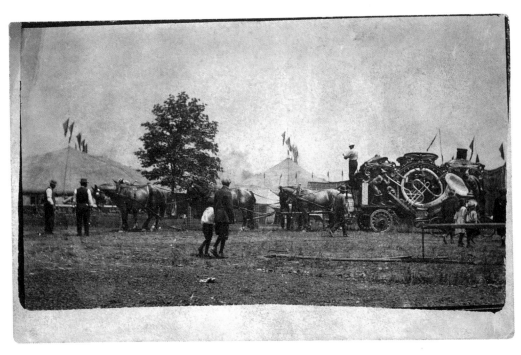

Calliope. 1910–1918.

ca. 1912.

¶ Thomas Edison's cylinder phonograph first became available for home entertainment in the late 1880s and 1890s. By the time this image was made, discs were replacing cylinders, but Edison continued to favor cylinders for another decade. This appears to be Edison's Opera model phonograph introduced ca. 1912, posed with an Edison 4-minute Amberol record cylinder, a family photograph, and sleeping dog.

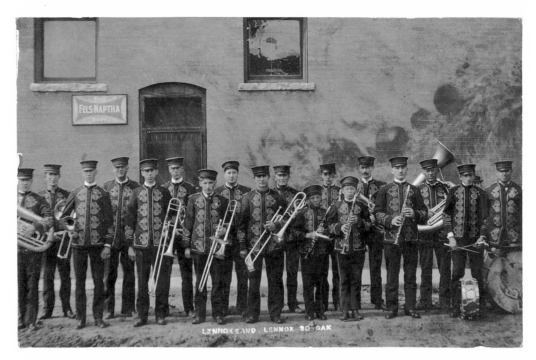

Town band. Lennox, South Dakota. 1909.

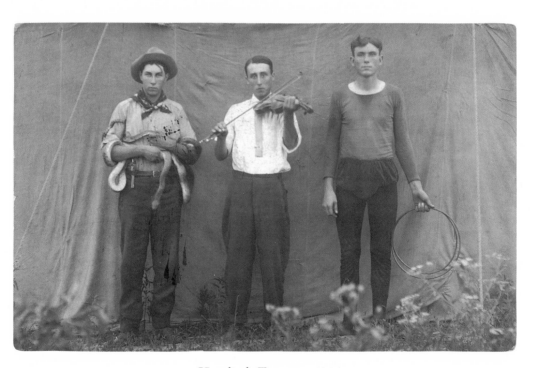

Hornbeak, Tennessee. 1913.

"Hellow Sister. This is one of our pictures that I told you about. The fellow with the fiddle is Mr. Carlton. The other is Lloyd. From your brother, Henry Cathcart."

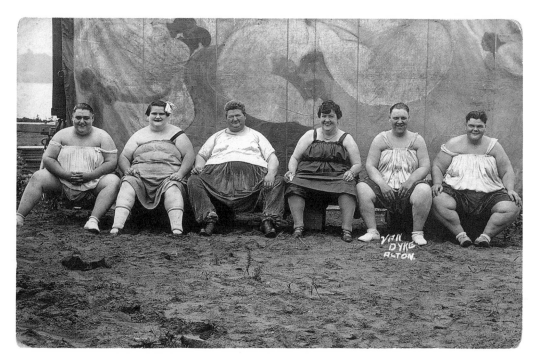

Photo by Van Dyke, Alton. 1920s. Courtesy of Rodger Kingston.

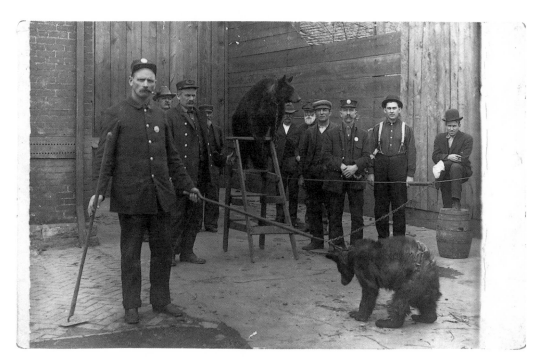

Captive bears. Michigan. 1908.

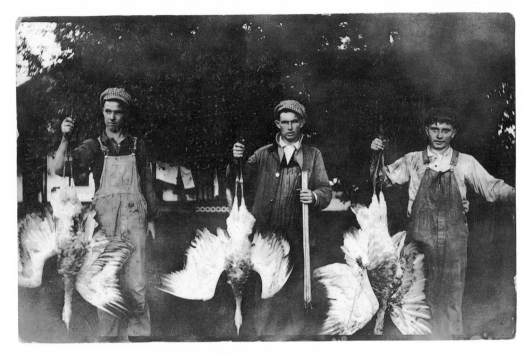

Cranes. 1910–1916.

¶ Until the Migratory Bird Treaty Act of 1916, birds such as these were slaughtered by the thousands for sport and feathers. This image proclaims the nation's bounty: infinite space, resources, and game.

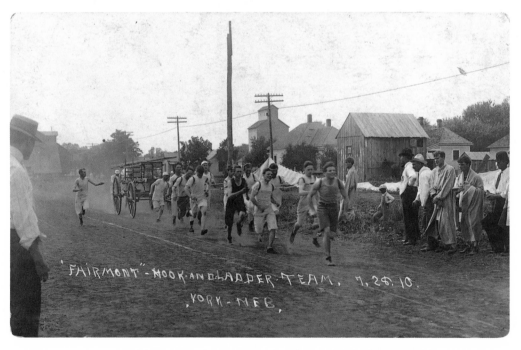

Hook and ladder team. York, Nebraska. July 28, 1910.

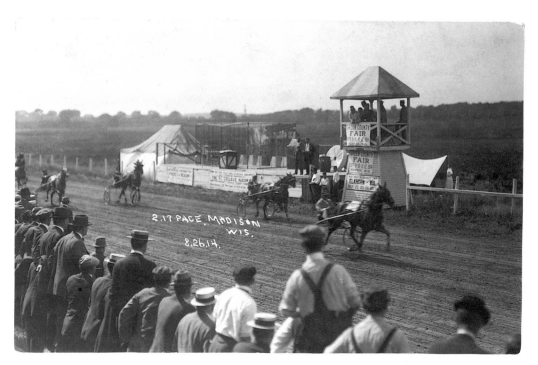

County fair. Madison, Wisconsin.
Photo by W. F. Trukenbrod, Monroe, Wisconsin. 1914.

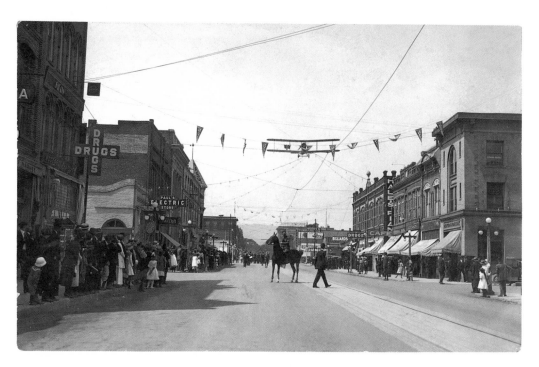

Medford, Oregon. 1918–1920.

¶ A crowd gathers for the excitement on and over Medford's main street.

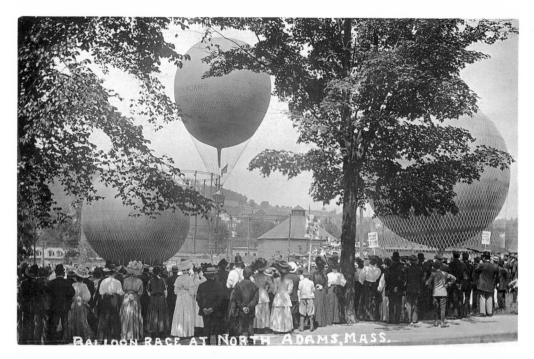

Balloon race. North Adams, Massachusetts. 1907–1912.

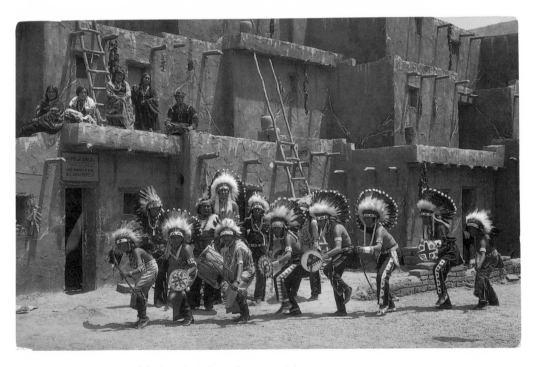

Native American dancers. Arizona. 1913–1914.

¶ A sign over the doorway reads: HOPIS AND NAVAJOS in this exhibit are from the Hopi Indian Reservation in northern Arizona and ARE WARDS OF THE U.S. GOVERNMENT. The camera records a performance for visitors and provides eloquent evidence of Native American status.

1909−1912.

¶ The kid is flying—released into the sky by the earthbound male foursome below. Perhaps the photographer saw hope for the future soaring in his image. Pure play, this is probably an amateur photo, but whoever the photographer, the moment is perfectly caught.

College girls at Silver Bay. New York. J. S. Wooley, Ballston Spa, New York. 1913.

"I guess by the picture that the College girls have fully as good a time as we do. Am having a stiff course of studies this year. Have you got your auto yet? Would very much like to hear from you. Henry."

¶ Silver Bay was a popular Adirondack resort, and Wooley its official photographer.

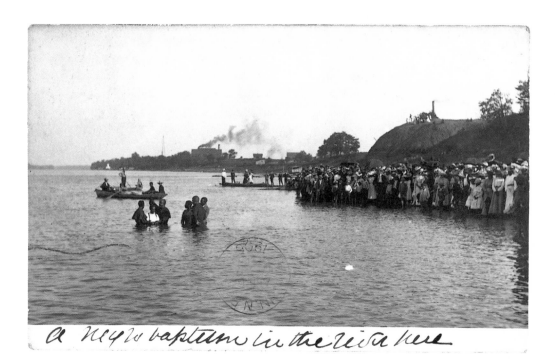

Baptism. New Decatur, Alabama. 1906.

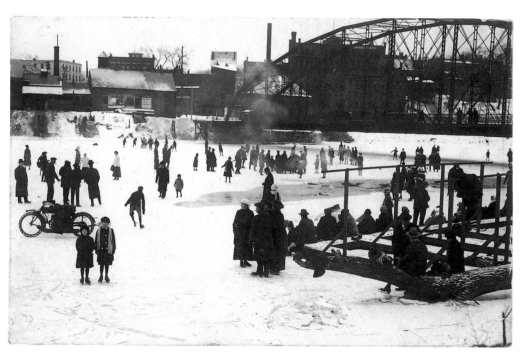

Skating on a river. Unknown city. 1910–1918.

ca. 1912.

¶ This truck driver is equipped for his open-air task on muddy roads with protective jacket and leggings, cap, and heavy leather gloves.

1910–1912.

¶ A proud crew sits on brand new motorized fire truck for a portrait.

TRANPORTATION

TRAIN, airplane, automobile, and other transportation modes—both new and old—were popular subjects. The automobile was becoming a prized possession and spur to greater mobility, social freedom, and independence. Throughout the nation, new and paved roads were being built, and a national highway system was begun after passage of the Federal Highway Act of 1921. A town owned no more admired and valued piece of equipment than a new fire engine.

Lemonweir River Bridge, Mauston, Wisconsin.
Photo by The Northern Photo Co, Wausau, Wisconsin. 1911.

¶ The automobile inspired some apprehension and even outright hostility. A sign on the bridge reads, "Five dollar fine for driving on this bridge faster than a walk."

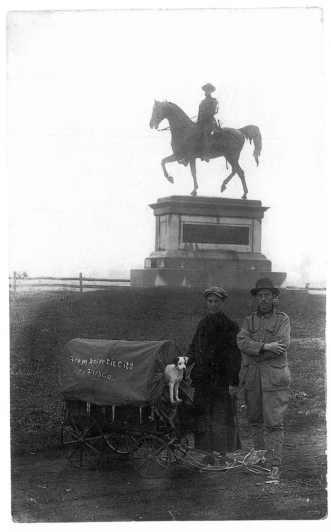

Walkers. From Atlantic City to Frisco. 1915.

"Nov. 24th. Mr. and Mrs. Robert Hunter left Atlantic City Oct. 1st, 1915."

¶ Cross-country walks took months and captured the popular imagination.

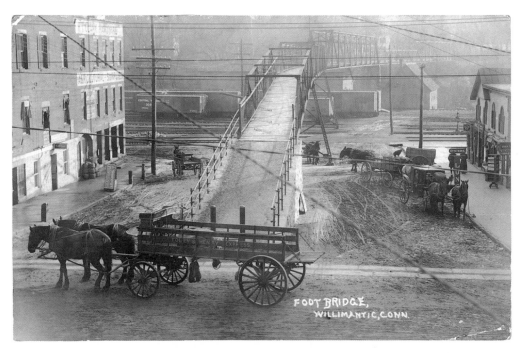

Footbridge. Willimantic, Connecticut. 1908.

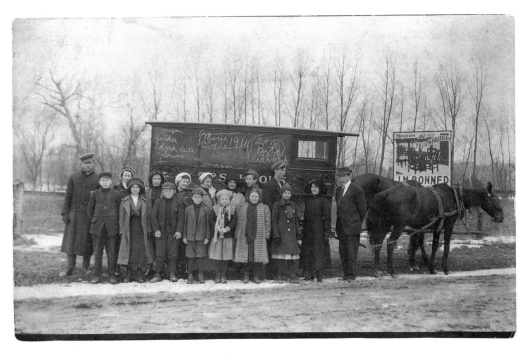

School wagon. 1910–1918.

Howard Roby in buggy. 1910–1918.

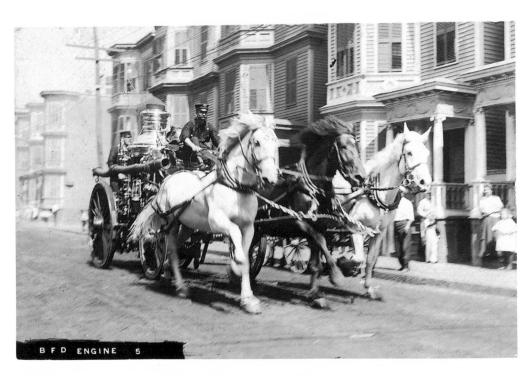

BFD ENGINE 5

Engine 5. Boston, Massachusetts. 1911.

"The pictures that I tried to take when I was there were a failure. None of them came out at all, very sorry. Capt. M. R. Joy, East Boston, Engine No. 5."

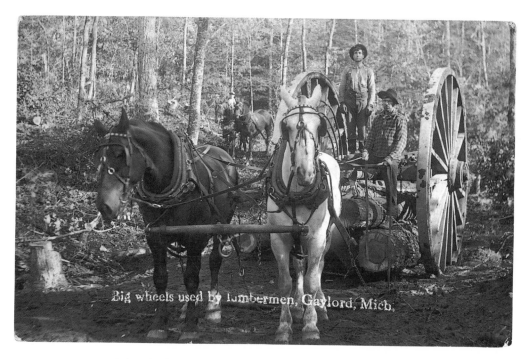

Big wheels used by lumbermen. Gaylord, Michigan. 1914.

"We are about ready to thresh and I will write when I am not so busy. Hurry home. Big times coming. HRF"

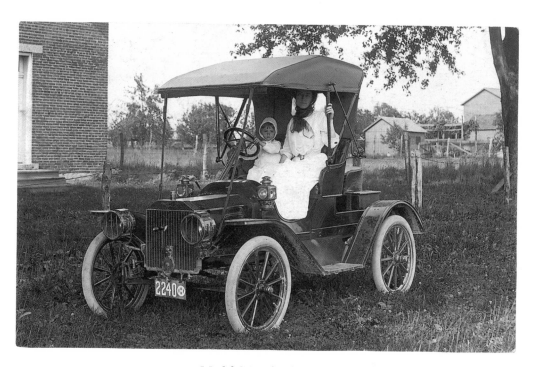

Model S Ford. Ohio. 1908.

¶ The child's handprint on the dusty fender brings this image right into our time and space.

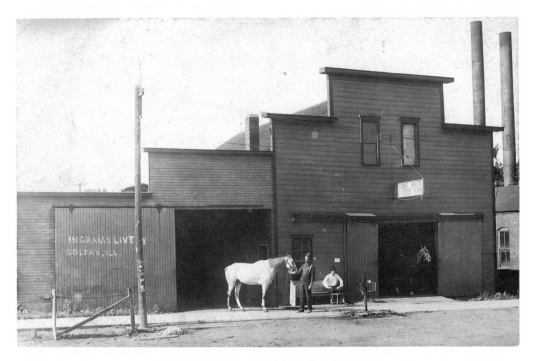

Ingram's Livery. Colfax, Illinois. 1909.

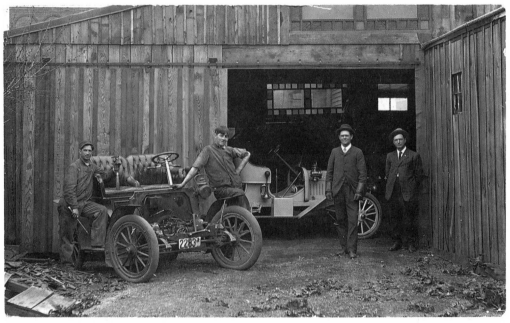

Garage. Wapello, Iowa. 1909. Courtesy of Rodney C. Brunsell.

"This is the rear end of our garage. The man with the gloves on is the boss.
The white car is a Buick and the fastest thing in the world in the auto line,
running 100 mi in 99 min. Going some isn't it!"
¶ From livery and feed barn to garage and gasoline: momentous change.

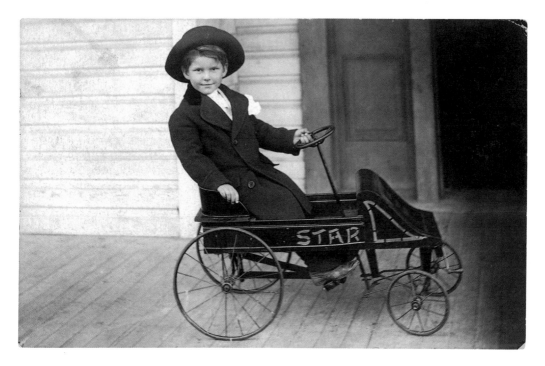

1908–1912.

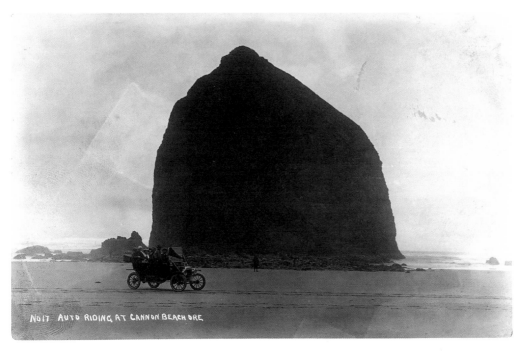

Cannon Beach. Oregon. Patton Post Card Co., Salem, Oregon. 1910–1918.

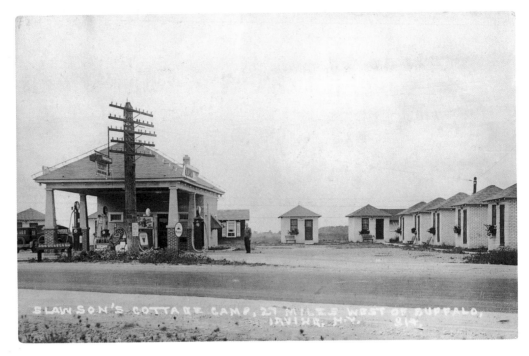

Slawson's Cottage Camp. Irvine, New York.
Eastern Illustrating Co., Belfast, Maine. 1920s.

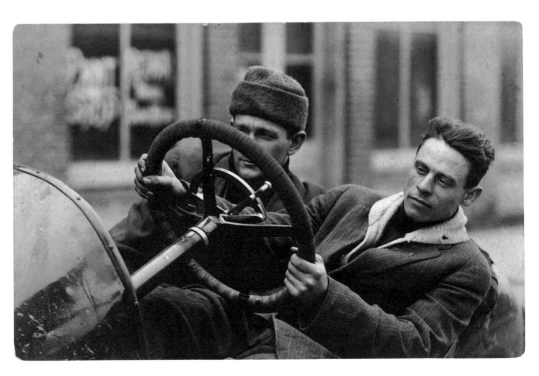

At the wheel of a racing car. ca. 1908.

Starting the race. Illinois. 1913.

"Dear Mother: Here is a picture of the race. Not one accident.
You've got to hand it to the Indian. Otto."

¶ Produced from 1901 to 1953, the American-made Indian motorcycle was hugely popular for the road, cross country, and racing.

Race checkpoint. 1910–1912.

Baker, Montana. Erther photo. 1912.

¶ Grain elevators stand alongside railroad tracks that connect Montana's farm production with distant markets.

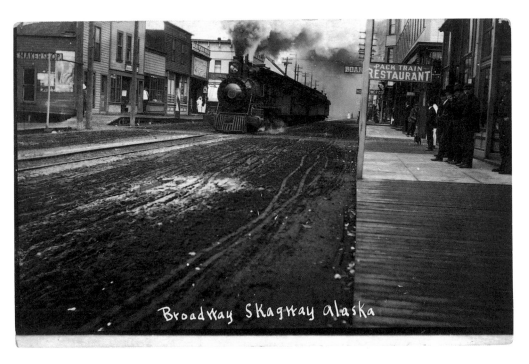

Broadway. Skagway, Alaska. 1910–1918.

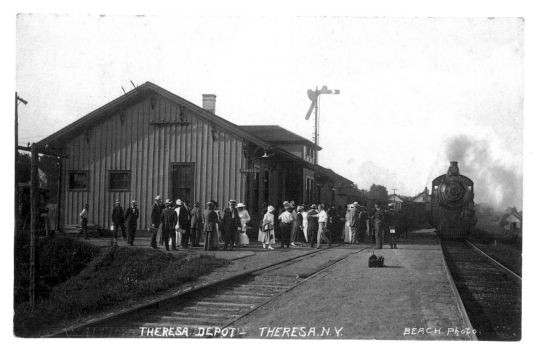

Depot. Theresa, New York. Beach Photo. ca. 1912.

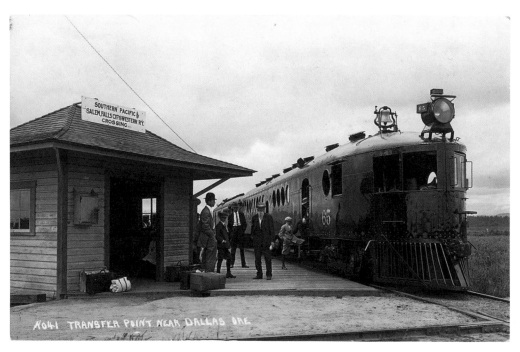

Transfer point near Dallas, Oregon. 1910–1918.

¶ By 1914, a network of railroad lines linked all regions of the country.

The Virginia Dare.
Photo by Lindsay, Newcastle, Maine. 1920s.
Courtesy of Rodger Kingston.

¶ Note the scale of the workers in relationship to the ship's hull.

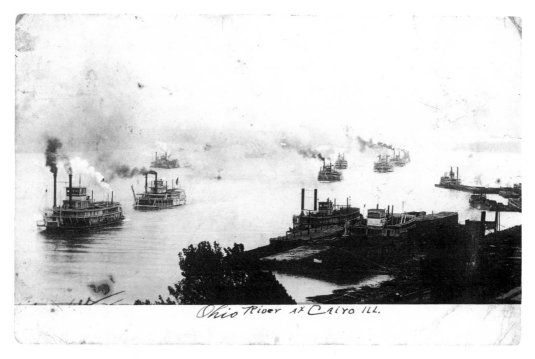

Steamship Alley. Ohio River at Cairo, Illinois. 1912.

From Willie in McClure, Illinois, to Mary across the Mississippi in Jackson, Missouri: "I was intending to come over Saturday but you know it had to rain. Next time I am not going to tell anyone when I am going and go the first pretty day. . . ."

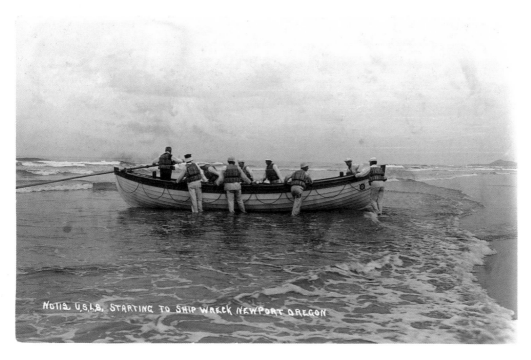

Lifeboat. Newport, Oregon. Patton Post Card Co., Salem, Oregon. 1910–1918.

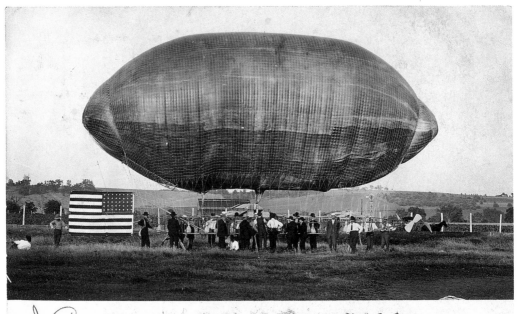

Captain Baldwin's air ship. Clarinda, Iowa. July 4, 1907. Courtesy of Andy Griscom.

¶ Baldwin and his air ship were popular attractions at fairs and air shows.

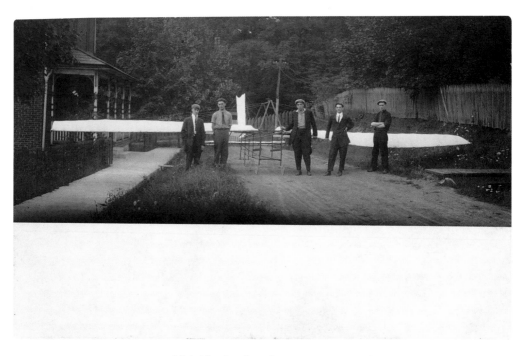

Neighborhood project. 1910–1918.

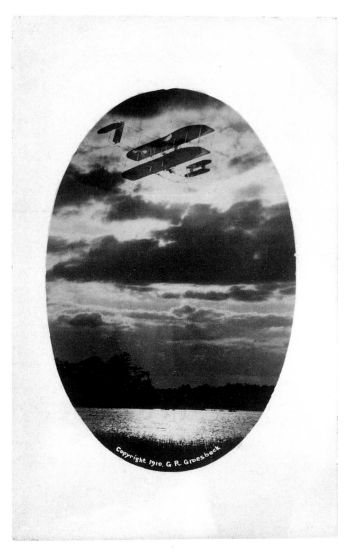

Photo by G. R. Groesbeck.
Published by Moehring and Groesbeck Postcards and
Art Novelties, Lynn, Massachusetts. 1910.

¶ Probably taken at the Harvard Boston Aero Meet, this image shows a Wright Brothers biplane in flight.

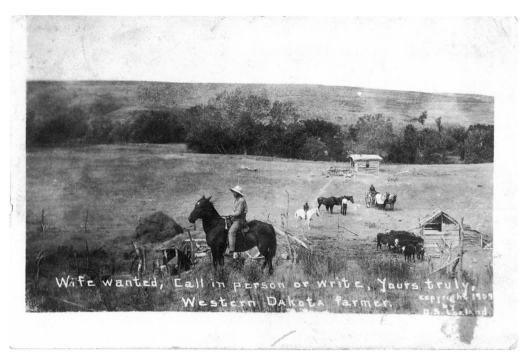

South Dakota. Photo by O. S. Leeland. 1909.

"Dear Sister, Ellen and the children are well and seem to like it here. The crops are pretty good. Yours truly, Albert"

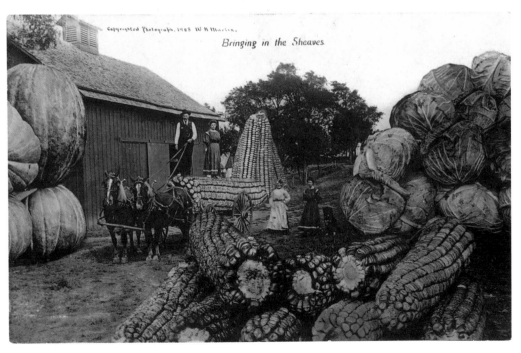

Bringing in the Sheaves. W. H. Martin photograph. 1908.

¶ An example of Martin's humor and cut-and-paste photomontage.

PART THREE

Encounters and Reflections

Because "real photo" cards were part of a bigger consuming trend, that of postcard sending and collecting, and because they connected so closely with the kinds of Americans who were helping to define twentieth-century America—immigrant, farmer, mill worker, small-town resident, city dweller, shop owner, railroad worker, traveler, etc., from all parts of the country—their images encompassed all kinds of subjects. I have touched on the most common areas, but I have omitted others. Natural wonders, public monuments, beloved landscape vistas were widely photographed for "real photo" postcards, as they were for mass-printed ones. Humor, oddities, and eroticism were also in the "real photo" repertory. Also omitted from my discussion are stereographic and miniature postcards, which comprised a miniscule part of "real photo" production.

While I have covered many areas of "real photo," there are other ways of approaching this material to understand how these cards were used and made. Two examples follow.

And finally, I reflect on the passing of these remarkable images and what they offer us now in this very different era.

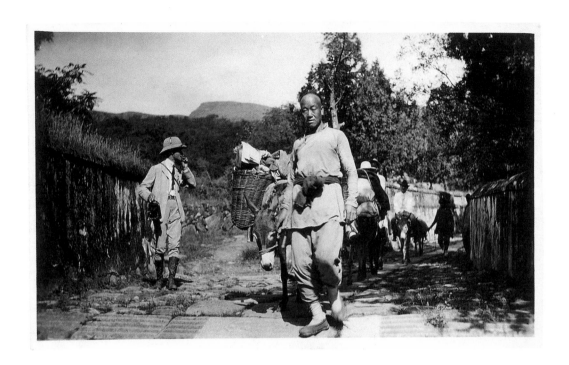

J. V. A. MacMurray, camera in hand, alongside procession of coolies
and donkeys carrying baggage. ca. 1916.

¶ MacMurray describes his camera as a "splendid old lens fitted into a new but rather elaborate shutter attached to the body of a regular folding Kodak." He particularly liked the Kodak because of its portability.

[CHAPTER FOURTEEN]

AN AMERICAN ABROAD

JUST as war occasioned "real photo" postcards, there were other reasons for American photo cards abroad. Travel, diplomacy, and foreign residence were subjects for the 3A camera, and Kodak's international presence facilitated the process.

J. V. A. MacMurray's legacy grew out of international relations and diplomacy, and he left a vast collection of photographs made during various diplomatic postings. He was born in 1881 into a military family, to a father who viewed photography as a military art, and although surveillance was never part of MacMurray's interest or intention, he did learn to use a camera so that photography became an important part of his life. MacMurray's father also taught him how to handle a horse, a skill and vantage point that he used to good purpose as a young amateur photographer.

MacMurray, a graduate of Princeton University and Columbia Law School, had a distinguished career in the foreign service, holding posts in China, Siam, Russia, Japan, and Turkey under Presidents Harding, Coolidge, Hoover, and Roosevelt. He died in 1960, leaving his papers to Princeton University.

He was assigned to the American legation in Peking intermittently from 1913 to 1929, and from 1925 to 1929 he was the American minister there.[1] While MacMurray would return later to China, it was during his first posting as a young foreign service officer that he produced what his daughter believes was his largest and most beautiful body of photographic work. These years also corresponded to the peak "real photo" era, and much of his work appears in postcard form. His daughter, who has most of his photographic archive and has seen the cards sent home to America from China, contends that her father consciously selected this medium of correspondence. He recognized that photography offered him

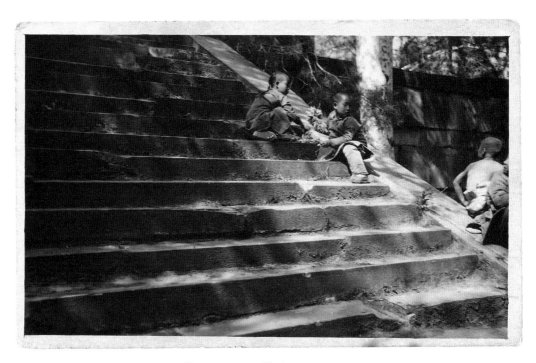

Boys on steps. Christmas, 1916.

a way to really *see* China; it would also allow him to communicate with loved ones at home—his mother, his sisters and others—in a special way. His communications would be both personal and objective, would convey his view of his new world through visual image as well as words. The "real photo" postcard met his needs, permitting a correspondence that combined frequency, verbal brevity, and visual eloquence. After his death, his daughter found some of his early postcards, not sent but addressed with messages prepared in advance to his mother, so as to be sure she heard from him on a near daily basis.

MacMurray kept meticulous records. It was an extraordinary experience to sit in his daughter's living room and open an album that contained page after page of film negatives and positive prints, each identified, of his many postcard images—fifteen hundred made during his six-year posting. Some had identifying words exposed into the negative that were then developed out on the photographic print, indicating the use of an autographic camera. While he was well-schooled in the craft and technology of the camera, he did not develop his own photographs, a practice apparently typical of many other skilled amateur photographers. This he left to

Road in the hills. 1916.

"Our temple is on the little path to the left.
The boys are just coming down from it."

¶ These postcards were sent from Peking to MacMurray's sister-in-law in 1916.

the Peking Camera Shop where his films were developed and images printed in soft brown tones onto Kodak postcard paper by the German-born proprietor. His choice of warm tones and soft-focus was consistent with his imagery, the landscape, and ancient monuments of China. All reflect his romanticism toward China, a land rooted in the past but beginning to undergo what this sensitive young diplomat could see would be radical change in the twentieth century.

MacMurray in some respects could be likened to the amateur photographer of the previous century: he photographed as an artist and an explorer, using the camera as a tool of discovery to record his encounter with an ancient, exquisite, and unfamiliar culture and landscape. But the twentieth-century "real photo" postcard gave him a means of sharing his work with his family in the distant western and modern New World. In that sense, his work becomes intimate and personal, a link between old and new, East and West, son and mother.

VIRGINIA'S ALBUM

At the summit of a residential street that ascends to one of my town's highest elevations, sits a handsome brick Colonial Revival building. Built between 1893 and 1897 as a single-family residence, the property was soon divided into two dwellings, 94 and 98 Addington Road, shown as two separate lots and homes by 1900 and as residential apartments in the same configuration today. From 1905 to 1946, 94 Addington Road was owned by Hattie and Henry McDewell, and until 1914, at least, was their Brookline, Massachusetts, residence with their sons, Rae and Harrie, and daughter Virginia.[2] I first encountered the McDewell family in Allentown, Pennsylvania, where I discovered Virginia's postcard album among reams of photographic material stashed in a footlocker in a warehouse full of antiques. It seemed remarkable to find this treasure from my own community, and even more remarkable that the album should be intact, presumably with every postcard just as Virginia had placed it. The inside cover is inscribed "Virginia from Chandler 1905." Chandler's identity eludes us, and there are no longer McDewells in Brookline; but gradually, through the cards in the album, one becomes acquainted with this family.

The album contains 126 cards. Of these, thirteen are "real photo," and among those, seven are family photographs. Sixty-four are collotype and other color printed cards; seventy-seven were mailed; twenty were sent from Europe. The cards date from April 1905 to 1909, but the majority are from 1905 and early 1906. One of the earliest cards was sent to Mrs. H. McDewell at 373 Harvard Street in April 1905, indicating a move to Addington Road sometime after that date. Many were sent to Virginia by her father, mother, brothers, and older married sister; but family members seemed willing to share the cards they had received, so they, too, went into the album. Her father traveled on business and wrote regularly to his family, letting them know where he was, how work and travel were going, of-

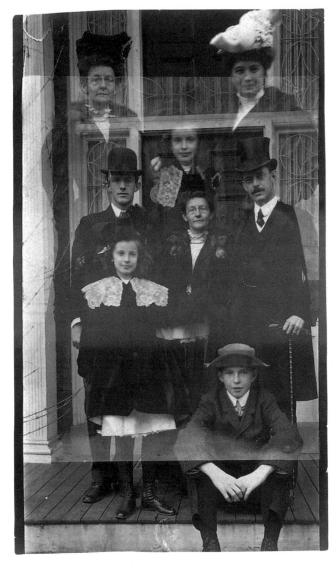

The McDewell Family, double-exposed. 1905.

fering advice on maintaining the home front, telling them how much he missed them. In the fall of 1905, he sends cards from Clarksburg, West Virginia; Washington, D.C.; Cincinnati, Ohio; Springfield, Massachusetts; Hartford and New Haven, Connecticut. In early 1906, he writes from Pineville, Kentucky, and Nashville, Tennessee, and in 1907 from Philadelphia, Pennsylvania, and Lakewood, New Jersey. A set of views of Louisville,

Kentucky, and of the Baltimore & Ohio Railroad, unmailed, are in the album. When "Pa" was away, he missed his family; his cards seem equivalent to a later era's long-distance phone calls.

Older brother, Rae, both receives and sends correspondence: to his mother, to Virginia "for your album," or from a friend to arrange a week-end tennis game. Virginia's married sister, Edith, lives with her husband in Minneapolis. She signs her cards EEDS, and keeps in touch via cards to her brother "Harry" (Edith's spelling), Virginia, and her mother. Occasionally "Ma" accompanies "Pa" on his travels, as she did to Washington and Philadelphia in March 1907, and she, too, sends postcards back to Brookline. Friends and relatives send cards as well, from travels and vacation spots in New England. In September 1906, "Cousin Ethan" sends a card from Maine to Virginia in Silver Lake, New Hampshire, where the family apparently vacationed and where her father lives by the 1940s. A European trip for Virginia with her parents in March 1906 is documented by the postcards: she sends some to Harrie who remained at home, and Rae receives cards from Pompeii and Genoa. Harrie reciprocates with a number of cards sent to "Ma" and Virginia the next month on a visit to New York City. The album contains numerous unmailed souvenir cards, not only from the European trip, but also from Boston and New York City.

The photo cards, all probably taken in 1905, help bring the family into focus. In one, we meet "Ma" and "Pa," Harrie and Rae; in another, Harrie and a friend; then Harrie and Virginia playing croquet. Edith and George stand in the Minnesota snow, and Edith sends her mother a card of herself with her dog, Fluffy, a pet apparently known to Brookline family members. There are two images taken on the front steps of their new home at 94 Addington Road: "Ma," Edith, and Virginia; "Ma," "Pa," Rae, Harrie, and Virginia, this a double exposure. Virginia appears to be about twelve years old; Harrie is younger, perhaps ten, and Rae, nineteen or twenty. Though the correspondence never alludes to picture making or the use of a camera, these photo postcards appear to have been made by a neighbor or family member rather than by a professional photographer. The remaining photographic cards, professionally made, are scenes of the Hotel Astor in New York, where "Pa" stayed when he traveled. Of these "real photo" cards, only those from Edith in Minnesota had been mailed.

The postcard album seems a typical one, with varied kinds of cards illustrating family activities and relationships, work, play, and travel.

Virginia's album was an altogether appealing project for twelve- or thirteen-year-old hands, offering education, entertainment, and memories for its maker and her circle, and a family chronicle that still speaks to us nearly a century later.

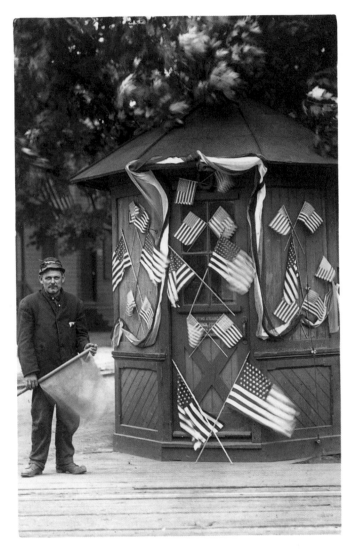

Photo by J. F. Fasnacht, Harrisburg, Pennsylvania.
1913–1914.

THEN AND NOW

WHAT makes these postcards from the past so appealing to us now? Photographs of anonymous people and unfamiliar places and messages from total strangers exercise their power over me and others, we who scan the images for details or subtexts. Does this place still exist (or we know it no longer exists), what's going to happen next, where were these people going, what else was part of their lives, what will become of them? We're face to face with both their moment of reality in the card and their absolute transience. They existed at that moment in time and they continue to exist in that moment, but only in the image. Reality and mortality were bound together in countless small rectangular paper photographs—photographs sent unprotected through the mail.

"The photograph is a certain but fugitive testimony."[3] This ephemeral quality—the postcard's smallness, its paper plainness, its material insignificance, its tendency to fade or crease, its propensity to be held and looked at, to be discarded, sent away, shared, or put away—heightens its appeal. Utterly mundane and disposable, these little survivors engage us. We read the messages—some in pencil, some in pen. Some make no allusion to the photo contents; some seem absurdly ill-suited to the image; some disparage the likeness yet send it and hope for one in return; some speak proudly of who or what is in the photograph. Like the images, the messages are seldom momentous, but they are personal and revealing and the stuff of everyday reality.

We have seen that these cards played a powerful social, communications, and documentary role during their own era. We recognize their ability to connect us with the past through the strength of their imagery, their engaging individual detail, the language of their signs, and their evocative power. But "real photo" production as we have seen it was closing down by the late 1920s. Velox postcards were last listed in Kodak's

197

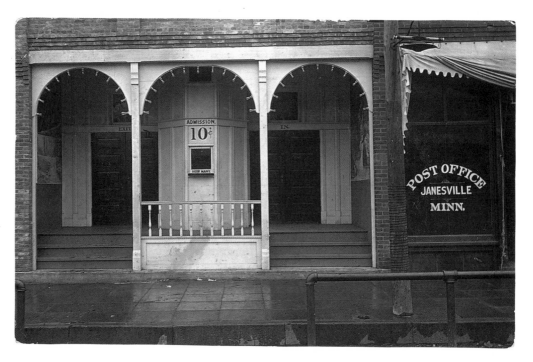

Princess Theatre. Janesville, Minnesota. 1913.

"Thought I'd just drop you a card to show you the picture of the new Princess Theatre. Louie B. gave me this one when I walked home with him this noon."

1931 catalogue, their demise only partly attributable to the Great Depression.[4] Photographic postcards continued to have some popularity until after World War II, and high resolution photography defines mass-printed postcards today. Amateur photographers continue to make and preserve photographs, but few make them up into postcards.[5] "Real photo" postcards from the first two decades differed from their successors. How and why?

I believe these differences have to do with the interface of social and technological change in twentieth-century America. The early years of that century were years of burgeoning technological innovation and change, of population shifts and increases, of increased urbanization, of growth and optimism. It was a time of transition. The nation was still defining itself. The West had been won, and old frontiers were developing into population centers. The new Americans from the great turn-of-the-century waves of immigration were assimilating and providing

tional Art Views Co., the Rotograph Co, and Souvenir Post Card Co., all New York; and American Art Post Card Co., Boston Post Card Co., the Leighton & Valentine Co., Mason Bros. & Co., Metropolitan News Co., the New England News Co., Reichner Bros., Robbins Bros. Co., Thomson & Thomson, Tichnor Bros. Inc., United Art Co., all Boston or Boston and New York. Detroit Publishing Co. with collotype "Phostint," Edward H. Mitchell, and the Valentines, unlike most others, printed their cards in the United States and were clearly proud of their exceptional postcard images.

24 Gisèle Freund, *Photography and Society* (Boston: David R. Godine, 1980), 100.

25 *Kodak Trade Circular*, October 1903, 4.

26 *Kodak Trade Circular*, April 1907, 6. Today we refer to the written side of the card as the "back," indicating the primacy of image on the "front" or "face" of the card.

27 *Cartes de visite* were calling-card size mounted photographs introduced from France to the United States in 1860. They were popular worldwide through the 1880s. Larger cabinet cards (4 ¼"x6 ½") appeared in the late 1860s and continued in use until the early 1900s.

28 Fanelli and Godoli, 16.

29 Paul J. Vanderwood and Frank N. Samponaro, *Border Fury: A Picture Postcard Record of Mexico's Revolution and U.S. War Preparedness, 1910–1917* (Albuquerque: University of New Mexico Press, 1988), 6–7.

Chapter 5

30 George Gilbert, *Collecting Photographica* (New York: Hawthorn/Dutton, 1976), 254–255. David A. Gibson, Technology Department, George Eastman House Archive, points out that the latest model was the No. 3A Kodak Series II camera which was produced between 1936 and 1941.

31 Catalogue of Kodaks and Kodak Supplies, 1911, 17.

32 *Kodak Trade Circulars*, June 1909, 11; December 1916, 3.

33 Catalogue of Kodaks and Kodak Supplies, 1903, 63.

34 Catalogue of Kodaks and Kodak Supplies, 1903, 7.

35 *Kodak Trade Circular*, May 1910, 7. R.O.C. was the Rochester Optical Company, acquired by Kodak in 1903, one of numerous independent potential competitors first encouraged and then absorbed by Eastman Kodak.

36 *Kodak Trade Circular*, June 1904, 7.

37 Hal Morgan and Andreas Brown, *Prairie Fires and Paper Moons, The American Photographic Postcard: 1900–1920* (Boston: David R. Godine, 1981), xiv.

38 *Kodak Trade Circular*, March 1906, 2.

39 It is worth noting that the earliest paper photographs were all a result of the "printing out" process that used light to elicit a positive image. It was only in the 1880s that photographs were "developed" through chemical solutions, and after 1900 most photo prints were made this way. Seeing commercial possibilities, Eastman adapted this old-fashioned process (still used for engineering and architectural blueprints) for amateur postcard use.

40 Courtesy, George Eastman House Archive, Rochester, NY

41 Cyko Manual, Ansco Company, Binghamton, NY, 26–27. Instructions were much the same in later manuals, for example, Cyko Paper, 1914, and Cyko Prints, 1918.

42 Information on Graber machine, courtesy, David A. Gibson, Technology Department, George Eastman House Archive.

43 *Kodak Trade Circular*, August 1914, 16.

44 *Kodak Trade Circular*, June 1908, 5–6.

Chapter 6

45 Jody Blake and Jeannette Lasansky, *Rural Delivery, Real Photo Postcards from Central Pennsylvania, 1905–1935* (Lewisburg, PA: Union County Historical Society, 1996), 19.

46 The Getty Research Institute in Los Angeles has more than ten thousand American photographic postcards from the Andreas Brown Collection. Photographer Walker Evans's interest in turn-of-the-century postcards of all kinds may also bear fruit as his own collections become more available for study and review.

47 *Kodak Trade Circular*, May 1908, 6.

48 Colin Ford and Karl Steinorth, eds. *You Press the Button We Do The Rest: The Birth of Snapshot Photography* (London: Dirk Nishen Publishing in association with the National Museum of Photography, Film and Television, 1988), 28–29.

PART II

1 Morgan and Brown, 187–190.

2 George C. Gibbs, *The Real-Photo Locator* (Latham, NY: Historic Originals, 1987, 1994).

Chapter 7

3 W. S. Harriman Collection, Ohio Historical Society, Columbus, OH.

4 Glenn K. Harriman, interviews by author, Columbus, OH, 1995, 1999.

5 Thomson & Thomson and New England News Co. Collection, Society for the Preservation of New England Antiquities (SPNEA), Boston, MA. SPNEA has about three thousand photographic prints (no original negatives) plus original records from these two Boston companies. Records include instructions to photographers as well as to colorists; printing was usually done in Germany. The collection offers graphic evidence of the evolution from original photo image to the kind of mechanically manufactured postcard product so popular in the early 1900s.

6 Town and county records shed little light on Richardson. The only references are the following: a building, identified with the name "Richardson" and surely the studio, is shown on a 1907 map of Chatham's Main Street. In 1912, a program booklet for Old Home Week credits the Richardson Studio with helping provide views of the 1912 celebration. Charles Smallhoff is, however, listed as the official Old Home Week photographer. Richardson's first name eludes us. According to local historian,

Thomas Buckley, the Richardson Brothers of New York opened a studio in 1902 on Chatham's Main Street. In 1905, they bought and enlarged an existing business—presumably in the building shown on the 1907 map—and in 1912 Charles Smallhoff joined the studio. In 1914, the studio building was sold to make way for the development of the new Post Office block, and Smallhoff bought out the Richardsons' photography business, relocating to the Mayflower Shop across Main Street. New York City directories, from 1900 to 1918, show one listing in 1900 for a Frank Richardson, photographer, and no listing thereafter for any photographer(s) by the name of Richardson.

7 R. Brewster Harding, *Roadside New England 1900–1955* (Portland, ME: Old Port Publishing Co., 1982). Robert Bogdan's *Exposing the Wilderness*, (Syracuse University Press, 1999) explores the work of six Adirondack postcard photographers, including R. H. Cassens, of Eastern Illustrating and Publishing Company.

8 Eastern Illustrating and Publishing Co., for example, continued to issue old views, particularly in rural areas where change came slowly (Harding, 8). It is also possible that cards may have been printed on old stock.

Chapter 8

9 Vanderwood and Samponaro, 25.

10 Vanderwood and Samponaro, vii-x, 8–14 passim.

Chapter 9

11 *British Journal of Photography*, January 19, 1909, courtesy of David A. Gibson, Technology Department, George Eastman House Archive.

12 Estelle Jussim, *The Eternal Moment: Essays on the Photographic Image* (New York: Aperture Foundation, 1989), 174–175.

13 *This Fabulous Century*, Vol. 1, 1900–1910 (Time Life Books, 1969), 31.

14 Ben Maddow, *Edward Weston: Seventy Photographs* (Boston: New York Graphic Society, An Aperture Book, 1978), 37–38.

15 Peter C. Bunnell, ed., *Edward Weston on Photography* (Salt Lake City: Gibbs M. Smith, Inc. Peregrine Smith Books, 1983), 103–104. The J. Paul Getty Museum in Los Angeles has one Weston postcard from this period, a view of the newly laid out "Richardson tract" in Tropico.

16 Alan B. Newman, ed., *New England Reflections 1882–1907: Photographs by the Howes Brothers* (New York: Pantheon Books, 1981), x-xviii passim.

17 Newman, ix.

18 Walter Benjamin, "A Short History of Photography," in *Classic Essays on Photography*, ed. Trachtenberg, 204.

19 Joann Roe, *Frank Matsura: Frontier Photographer* (Seattle: Madrona Publishers, 1981).

20 Barthes, 13.

21 Alan Trachtenberg, *Reading American Photographs: Images as History, Mathew Brady*

to Walker Evans (New York: Hill and Wang, Division of Farrar Straus & Giroux, 1990), 29.

22 The tintype, with image exposed directly onto a thin pressed iron plate, had a relationship to the U.S. mail and a long lifespan, continuing until the 1920s. During the Civil War, its ferro-toughness made it a popular souvenir that could be sent via the mail to and from soldiers at the front. In the early 1900s, there are even miniature postcards made from the pressed metal tintype.

Chapter 10

23 Atget is known to have made some photographic postcards, but his great legacy is his albums of various Parisian subjects. We know that his work had no effect on American photographers during his lifetime, for it was only after 1930 that his work came to public attention in this country.

Chapter 11

24 Marianne Fulton, ed., *Pictorialism into Modernism, The Clarence H. White School of Photography* (New York: Rizzoli International Publications, George Eastman House, 1996), 18.

25 Vanderwood and Sampanaro, 3.

PART III
Chapter 14

1 At that time, the United States had few embassies, and only in countries of prime importance to U. S. interests. Most countries had U.S. legations through which they maintained diplomatic relations.

Chapter 15

2 A 1906 street list of poll tax payers includes male voters Henry M. McDewell, age forty-two, and Horatio S. McDewell (Rae Sprague McDewell on the postcards), age twenty at the 94 Addington Road address. They are listed through 1911, with no listing at no. 94 thereafter. Hattie E. McDewell appears as the owner of record on the Brookline Property Tax Lists from 1913 through the mid 1920s. Later tax lists show Henry McDewell (Silver Lake, NH), last listed in 1945.

Chapter 16

3 Barthes, 93.

4 Arnold R. Pilling, "Dating Early Photographs by Card Mounts and Other External Evidence," *Image* 17, no. 1 (March 1974): 15.

5 Henry Deeks, "real photo" dealer and Civil War historian from Maynard, MA, is one notable exception.

6 Michel Deguy, ed., *L'Amérique au fil des jours: cartes postales photographiques 1900–1920* (Paris: le Centre National de la Photographie, 1983).

POSTCARD PHOTOGRAPHERS
WORKING BEFORE 1930

An ever-growing list and perhaps a starting point for the reader, the names below
include photographers, studios, and other producers currently known to the author.

Abbott, Lee L. Dixfield, Maine
Abele, N. J. Sandusky, Ohio
Adams, George F. Moscow, Vermont
Adams, J. G. Chesterfield, Massachusetts
Altwater. Newport, Ohio
Ameden, Ernest. New York
American Photo Studio. Hempstead, Long Island, New York
Anderson. Pueblo, Colorado
Andrews Studio. Lakeport, New Hampshire
Arlington Studio. Defiance, Ohio
Atkin, F. M. Livingston, Montana
Austin. Steubenville, Ohio
Balbey, W. L. Richmond, Indiana
Barker. Virginia
Barrowclough Cards. Winnipeg, Canada.
Bates, Edward. Lawton, Oklahoma
Baum, J. K. Middletown, Pennsylvania
Bayles. Chillicothe, Illinois
Beach, Henry M. Remsen, New York
Bean, O. Crosby. Bangor, Maine
Beardsley. Willis, Michigan
Beebe, E. L. Kalkaska, Michigan
Benner, H. M. Hammondsport, New York
Bennett, Howard. New Comerstown, Ohio
Berry, I. A. Indian River, Michigan
Bicknell Mfg. Co. Portland, Maine
Blodgett. Belfast, Maine
Boland. Tacoma, Washington
Bowman, Walter Scot. Pendleton, Oregon
Bragg, B. H. Alstead, New Hampshire
Brawn, Grant. Portland, Oregon
Brothers, Nicholas A. Aberdeen, South Dakota
Bryan Post Card Co. Bryan, Ohio
Bull, Octavius (Ocie). Elverson, Pennsylvania

Bryan Post Card Co.

Burgess, Arthur. Columbus, Ohio
Burrell, D. T. Massachusetts
Burrell Photo. Oregon
Butcher, Solomon D., & Son. Kearney, Nebraska
Carter, H. H., Postcards. Lockport, Illinois
Chalmers, Geo. E. Rutland, Vermont
Chaplain, Urban W. Belmont, New Hampshire
Cheney, A. H. Stowe, Vermont
Cheney, A. L. Morrisville, Vermont
Childs, Charles R. Chicago, Illinois
Clark, Henry L. Fillmore, New York
Clark, J. W. Bellevue, Kentucky
Cleveland, C. T. Bay River, Minnesota
Colby, James M. (Colby's Studio). Wausau, Wisconsin
Collins, W. J. Rapid City, South Dakota
Colonial Badge Co. Basil, Ohio
Commercial Photographic Company. Davenport, Iowa
CoMo. Mason City, Iowa
CoMo Company. Minneapolis, Minnesota
Cook, L. L., Co. Lake Mills and Milwaukee, Wisconsin
Cook Photo. Belfast, Maine
Cook-Montgomery Co. Minneapolis, Minnesota
Crandall, W. S. Fillmore, New York
Cretors, S. M. Elgin, Illinois
Cross & Dimmitt. Oregon
Cunningham, Burt. Liberty, Maine
Cunningham, F. W. Liberty, Maine
DFP Co, Inc. Wyoming
Daniels Photo. Minnesota
Dedrick, John Virgil. Taloga, Oklahoma
Delaney, N. A.
DeMars, F. H., The Art Store. Winsted, Connecticut
Deming. Winsted, Connecticut
Denison, H. H. Barron, Wisconsin
Dillon, Vince. Stillwater, Oklahoma
Dimmitt. Oregon
Dingman, B. H. Plymouth, Wisconsin
Dittrich Studios. Atlantic City, New Jersey
Dornbush, Henry G. Kalamazoo, Michigan
Doubleday, Ralph Russell. Douglas, Arizona
Drake, J. D. Silverton, Oregon
Dressel, H. M. Springfield, Illinois

Henry L. Clark

N. A. Delaney

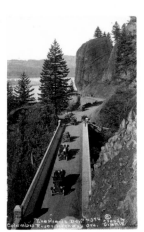

Cross & Dimmitt

Drum, Oscar. Bartlesville, Oklahoma
Dubois, O. E., Photo. Fall River, Massachusetts
Durham Photo. Princeton, Illinois
Eastern Illustrating & Publishing Co. Belfast, Maine
Eddys Studio. Southern Pines, North Carolina
Eisenhauer, U. H. Millmont, Pennsylvania
Erickson. Wilton, North Dakota
Erther Photo. Montana
Fahrbach. Jefferson, Iowa
Fasnacht, J. F. Harrisburg, Pennsylvania
Felger, C. H. Litchfield, Michigan
Fenn & Vogel. Michigan
Ferguson, Silas W. Worcester, New York
Fischer, H. P. (Fischer's Studio). Marietta, Ohio
Fletcher & Co. Orleans, Vermont
Folsom Studio. Canton, Ohio
Forbes, Andrew Alexander. Bishop, California
Forbes, the Kodak Man. Greenfield, Massachusetts
Foster, R. G. Freedom, New Hampshire
Fowler, Ambrose. New York, New York
Fowler's Photo Shop. Portsmouth, Ohio
Frasch, D. T. Seattle, Washington
Frasher, Burton. Lordsburg, California
Freshman, Charles. Jefferson Barracks, Missouri
Freter Bros. Bridgeport, Ohio
Fuller. Vermont
Gannett, J. K. North Scituate Beach, Massachusetts
Gibson Bros. Jacksonville, Florida
Glasier, Herbert E. Boston, Massachusetts
Graves, B. W. Vermont
Grenell, Charles E. Daytona Beach, Florida
Halbe, L. W. Dorrance, Kansas
Hall, George E. (Hall Photo Co.). Notch, Missouri
Hallman Studio. Berlin, Wisconsin
Hammond's Genuine Photograph. Yaphank, New York
Hancock Photo. Almont, Michigan
Hansen Photo Co. Withee, Wisconsin
Harriman, Wheldon Storrs. Columbus, Ohio
Harris Post Card Co. Pittston, Pennsylvania and Mt. Arlington, New Jersey
Harris, W. J. Pittston and Wilkes-Barre, Pennsylvania
Haugen, John R. Minnesota
Hayes, G. L. Connecticut

Eastern Illustrating
& Publishing Co.

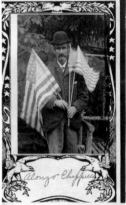

Hammond's Genuine
Photograph

Hayles. Rutland, Vermont
Hazeltine Bros. Oregon
Holmboe & White. New Salem, North Dakota
Holmes. Burlington, Vermont
Horne, Walter. H. El Paso, Texas
Horton, T. J. Hinckley, Minnesota
Houston, E. T. Waterbury, Vermont
Howard Studio. Warren, Ohio
Hunt Studio. Cherokee, Oklahoma
Huntoon Scenic Photo Publ. Co. Seattle, Washington
Huntress. Osterville, Massachusetts
Hurd, Nelson J. Glen Cove, Maine
Iowa Calendar Co. Marshalltown, Iowa
Jackson, George E. South Portland, Maine
Johnson, J. R. Cheboygan, Michigan
Johnson & Olson. Alexandria, Minnesota
Kase Studio. Omaha, Nebraska
Kaylor, C. F. Mishawaka, Indiana
Keith, John Frank. Philadelphia, Pennsylvania
Kellogg, P. H. Cuba, New York
Kepler. Lewistown, Pennsylvania
Kingsbury, Arthur J. Antigo, Wisconsin
Kline, E. C. Tatamy, Pennsylvania
Kollecker, Wm. Saranac Lake, New York
Kovar Photo. Nebraska
Laughlin, C. Shippensburg, Pennsylvania
Leeland, Ole S. Mitchell, South Dakota
Leighton, F. J. Taunton, Massachusetts
Leiter Post Card Co. Lorain, Ohio
Lindsay. Harrisburg, Pennsylvania
Lindsay. Newcastle, Maine.
Lomen Bros. Nome, Alaska
Long Mfg. Co. Anderson, Missouri
Long's Novelty House. Fort Wayne, Indiana
M. L. Photo Co. Chicago, Illinois
Mandeville, Wm. Garrett. Lowville Village, New York
Martin, M. B. Idaho
Martin, William H. (Martin Post Card Co.,
and North American Post Card Co.). Ottawa, Kansas
Mathews, E. Plattsburg, New York
Matsura, Frank. Okanogan, Washington
Mayflower Studio (Mayflower Shop). Chatham, Massachusetts

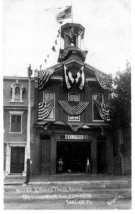

C. Laughlin

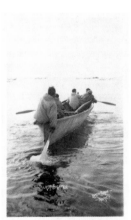

Lomen Bros.

E. C. Kline

210

McDougall & Keefe. Boothbay Harbor, Maine
McElfish. Frostburg, Maryland
McFadden, Fay. Granville, New York
McKeague, George A., Co. Atlantic City, New Jersey
Mercantile Studio. Philadelphia, Pennsylvania
Merrill, Elbridge Warren. Sitka, Alaska
Meyer, Herbert A., & Co. Jordan, New York
Miller, Byron Y. Bethel, Vermont
Miller, George. New York, New York
Miller, Charles Richard (Miller Photo Co.). Klamath Falls, Oregon
Minnear, T. Loyd. Zanesville, Ohio
Moehring & Groesbeck. Lynn, Massachusetts
Mole & Thomas. Chicago, Illinois
Montgomery, H. Hartford, Wisconsin
Moore & Hayward. Rutland, Vermont
Mowrey, W. H. Newport, Rhode Island
Myer, H. A. Jordan, New York
North American Post Card Co. Kansas City, Kansas
Northern Photo Co. Wausau, Wisconsin
Olsen, Fred. Hamburg, Roseglen, and Viking, North Dakota
Olson Photograph Co. Plattsmouth, Nebraska
Olson, W. O. Alexandria, Minnesota
Overbey's Studio. Mobile, Alabama
Owen, F. A., Publishing Co. Dansville, New York
Oxley, Walter T. Fergus Falls, Minnesota
Pacific Photo Co. (PPCo). Salem, Oregon
Palmquist. Milaca, Minnesota
Parfitt. Wisconsin
Patton Post Card Co. Salem, Oregon
Patz & Shepard. Hartford, Connecticut
Peck, Orson W. Traverse City, Michigan
Pederson Brothers. Skagway, Alaska
People's Studio. Roanoke, Virginia
Perry. Armour, South Dakota
Pesha, Louis (Pesha Photo Post Card Co.). Marine City, Michigan
Petris, Perry. South Dakota
Phelps, C. H. Sidney, New York
Photo Co. of America. Chicago, Illinois
Photo Crafts Co. Columbus, Ohio and Lebanon, New Hampshire
Pierce, Wright M. Claremont, California
Prentiss, A. M., & Co. Marshfield, Oregon
Price's Studios. Dover and Boonton, New Jersey

Fred Olsen

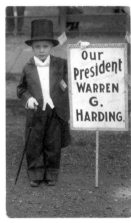

Price's Studios

211

Process Photo Studio

Process Photo Studio. Chicago, Illinois
R. and A. Postcard Co. Jamestown, New York
Rabineau, G. T. Lake Placid, New York
Radium Studio. Seattle, Washington
Raftice, Mrs. K. A. Carson City, Nevada
Reed, Charles. Norton, Kansas
Reed, E. A. New Hampshire
Reed, N. H. California
Reeves, C. S. Oregon
Reid, Hal. Liberal, Kansas
Richardson Studio. Chatham, Massachusetts
Richey, C. G. Columbus, Ohio
Richey Bros. Missouri
Riley, H. A. La Pine, South Carolina
Ritchie Bros. Centralia, Illinois
Rochester Photo Press. Rochester, New York
Rotograph Co. New York, New York
Roush, D. H. Clinton, Iowa
Ropa, Frank. Pleasantville, New Jersey
Runions, C. E. Star Lake, New York
Saiber. Wildwood, New Jersey
St. Clair Studio. Portsmouth, New Hampshire
St. Paul Souvenir Co. Minnesota
Schmidt Studio. Cleveland, Ohio
Schumann, A. J. Chicago, Illinois
Schwan's Studio. Mansfield, Ohio
Seidl, Jos. F. Hartford, Wisconsin
Sexton's Photo. Lena, Wisconsin
Shear, C. J. Ebenezer, New York
Shorey, Guy L. (Shorey Studio). Gorham, New Hampshire
Short. Rondout and Kingston, New York
Short Photo. Westerville, Ohio
Slack, C. C. Sioux Falls, South Dakota
Sloan, A. W. Emlenton, Pennsylvania
Slotes Studio. Cooperstown, New York
Smallhoff, Charles H. Chatham, Massachusetts
Smith, Albert. Manchester, Vermont
Spears & Fensty. Fort Terry, New York
Stevens, The Photo Man. Ames, Iowa
Steward, H. W. San Francisco, California
Stimson, Mary E. Montpelier, Vermont
Stone, J. New York

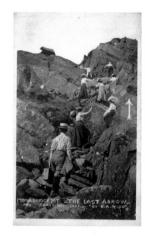

E. A. Reed

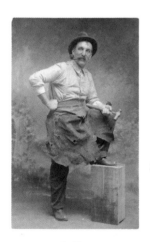

Saiber

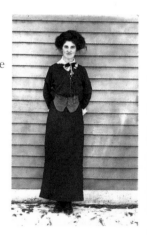

Spears & Fensty

212

Straffin, F. D. Idaho
Strauch. Champlain, Illinois
Sturm Studio. Cody, Wyoming
Stryker, John. Kearney, Nebraska
Sutfin, C. P. Westport, Oregon
Swinnerton, V. N. Omaha, Nebraska
Syverud, H. A. Highmore, South Dakota and Montana
Theo Photo. Odessa, Washington
Thomson, George C. Butte, Montana
Thorburn. Helmetta, New Jersey
Townsend, Charles A. Belfast, Maine
Troup, A. M. Barre, Vermont
Trukenbrod, W. F. Monroe, Wisconsin
Tucker, C. O. Boston, Massachusetts
Tyson & Son. Wamego, Kansas
Underwood. Elizabethtown and New York, New York
Underwood's Pharmacy. Klamath Falls, Oregon
Unique Post Card Co. Ellisburg, New York
Van Cleave. Wapello, Iowa
Van Dyke. Alton, Virginia or West Virginia
Violet Studio. Nashville, Tennessee
Walker. California
Walker, A. Xenia, Ohio
Walters, L. F. New York
Warriner Bros. Camp Douglas, Wisconsin
Wessa Photo. Wisconsin
Wheeler, S. S. Binghamton, New York
White Postcard Co. Ann Arbor, Michigan
Wilkerson, Thaddeus. New York, New York
Williams, C. U. Bloomington, Illinois
Williams Studio. Harbor Beach, Michigan
Winter & Pond. Juneau, Alaska
Wischmeyer, P. Seattle, Washington
Wolfe. Florida
Wood's Art & View Co. Des Moines, Iowa
Wooley, Jesse Sumner. Ballston Spa and Silver Bay, New York
Wootten Studio. New Bern, North Carolina
Wright, A. L. Sioux Falls, South Dakota
Yagear, Fred L. Panama, New York
Zimmerman, J. J. Alma, Wisconsin

Charles A. Townsend

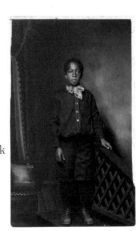

Violet Studio

Underwood

213

SELECTED BIBLIOGRAPHY

Allen, James, Hilton Als, John Lewis, and Leon F. Litwack. *Without Sanctuary, Lynching Photography in America.* Santa Fe: Twin Palms Publishers, 2000.

Allmen, Diane. *Official Price Guide to Postcards.* New York: House of Collectibles, 1990.

Baldwin, Gordon. *Looking at Photographs, A Guide to Technical Terms.* Malibu, CA: The J. Paul Getty Museum in association with British Museum Press, 1991.

Barthes, Roland. *Camera Lucida: Reflections on Photography.* New York: Hill and Wang, 1981.

Benjamin, Walter. *Illuminations.* Edited by Hannah Arendt. Translated by Harry Zohn. New York: Schocken Books, 1969.

Blake, Jody and Jeannette Lasansky. *Rural Delivery, Real Photo Postcards from Central Pennsylvania, 1905–1935.* Lewisburg, PA: Union County Historical Society, 1996.

Bogdan, Robert. *Exposing the Wilderness. Early Twentieth-Century Adirondack Postcard Photographers.* Syracuse: Syracuse University Press, 1999.

Brayer, Elizabeth. *George Eastman, A Biography.* Baltimore and London: The Johns Hopkins University Press, 1996.

Bunnell, Peter C. *Degrees of Guidance: Essays on Twentieth-Century American Photography.* Cambridge: Cambridge University Press, 1993.

Bunnell, Peter C., ed. *Edward Weston On Photography.* Salt Lake City: Gibbs M. Smith Inc., Peregrine Smith Books, 1983.

Chien, David. *About 85 Years Ago: Photo Postcards from America (circa 1907 to 1920).* Niwot, CO.: Roberts Rinehart Publishers, 1997.

Clark, Graham. *The Photograph* (Oxford History of Art). Oxford, New York: Oxford University Press, 1997.

Coe, Brian. *A Guide to Early Photographic Processes.* London: Victoria & Albert Museum, 1983.

Collins, Douglas. *The Story of Kodak.* New York: Harry N. Abrams, Inc., Publishers, 1990.

Deguy, Michel. *L'Amérique au fil des jours: cartes postales photographiques 1900–1920.* Paris: Le Centre National de la Photographie, 1983.

Fanelli, Giovanni and Ezio Godoli. *Art Nouveau Postcards.* New York: Rizzoli, 1987.

Ford, Colin and Karl Steinorth, eds. *You Press the Button We Do the Rest: The Birth of Snapshot Photography.* London: Dirk Nishen Publishing in association with National Museum of Photography, Film and Television, 1988.

Freund, Gisèle. *Photography and Society.* Boston: David R. Godine, 1980.

Fulton, Marianne, ed. *Pictorialism into Modernism, The Clarence H. White School of Photography*. New York: Rizzoli International Publications, George Eastman House, 1996.

Gibbs, George C. *The Real-Photo Locator*. Latham, NY: Historic Originals, 1987, 1994.

Gilbert, George. *Collecting Photographica*. New York: Hawthorn/Dutton, 1976.

Harding, R. Brewster. *Roadside New England 1900–1955*. Portland, ME: Old Port Publishing Co., 1982.

Janis, Eugenia Parry and Wendy MacNeil, eds. *Photography within the Humanities*. Wellesley, MA, and Danbury, NH: Wellesley College and Addison House Publishers, 1977.

Jussim, Estelle. *The Eternal Moment: Essays on the Photographic Image*. New York: Aperture Foundation, Inc., 1989.

Maddow, Ben. *Edward Weston: Seventy Photographs*. Boston: New York Graphic Society. An Aperture Book, 1978.

Malcolm, Janet. *Diana & Nikon: Essays on the Aesthetic of Photography*. Boston: David R. Godine, 1980.

Margolis, Marianne Fulton, ed. *Camera Work: A Pictorial Guide*. New York: Dover Publications, 1978.

McAndrews, Edward. *The American Indian Photo Post Card Book*. Los Angeles: Big Heart Publishing Company, 2002.

Mensel, Robert E. 'Kodakers Lying in Wait': Amateur Photography and the Right of Privacy in New York, 1885–1915," *American Quarterly*, vol. 43, no. 1. American Studies Association, 1991.

Morgan, Hal and Andreas Brown, *Prairie Fires and Paper Moons, The American Photographic Postcard: 1900–1920*. Boston: David R. Godine, Publisher, 1981.

Nesbit, Molly. *Atget's Seven Albums*. New Haven, London: Yale University Press, 1992.

Newhall, Beaumont. *The History of Photography*. New York: The Museum of Modern Art, 1982.

Newhall, Beaumont, ed. *Photography: Essays and Images, Illustrated Readings in the History of Photography*. New York: The Museum of Modern Art, 1980.

Newman, Alan B., ed. *New England Reflections 1882–1907: Photographs by the Howes Brothers*. New York: Pantheon Books, 1981.

Nicholson, Susan Brown. *Encyclopedia of Antique Postcards*. Radnor, PA: Wallace Homestead Books, 1994.

Photography: Discovery and Invention, Papers delivered at a symposium celebrating the invention of photography. Malibu, CA: The J. Paul Getty Museum, 1990.

Photography's Multiple Roles: Art, Document, Market, Science. Chicago: The Museum of Contemporary Photography, Columbia College, Chicago, and New York: D.A.P./Distributed Art Publishers, Inc., 1998.

Pilling, Arnold R. "Dating Early Photographs by Card Mounts and Other External Evidence." *Image* 17, no. 1 (March 1974): 11–16.

Rodgers, Patricia H. *Three for a Nickel: Martha's Vineyard Postcards 1900–1925*. Cambridge: Aqua Press, 2002.

Roe, Joann. *Frank Matsura: Frontier Photographer*. Seattle: Madrona Publishers, 1981.

Rosenblum, Naomi. *A World History of Photography*. New York, London, Paris: Abbeville Press, 1989.

Schor, Naomi. "Cartes Postales: Representing Paris 1900," *Critical Inquiry* 18. University of Chicago Press, 1982.

Sontag, Susan. *On Photography*. New York: Anchor Books/Doubleday, 1990.

Staff, Frank. *The Picture Postcard and Its Origins*. New York, Washington: Frederick A. Praeger Publishers, 1966.

Starkey, Lois MacMurray. *J. V. A. MacMurray: Diplomat and Photographer in China, 1913–1929*. Graduate Thesis, Harvard University Extension Studies, 1990.

Szarkowski, John. *The Photographer's Eye*. New York: The Museum of Modern Art, 1966.

Szarkowski, John. *Photography Until Now*. New York: The Museum of Modern Art, 1989.

Taft, Robert. *Photography and the American Scene: A Social History, 1839–1889*. New York: Dover Publications, Inc., 1964, 1938.

Tagg, John. *The Burden of Representation: Essays on Photographies and Histories*. Minneapolis: University of Minnesota Press, 1993.

This Fabulous Century, Vols. I, II, III. Alexandria, VA: Time Life Books, 1969.

Thomas, Alan. *Time in a Frame: Photography and the Nineteenth-Century Mind*. New York: Schocken Books, 1977.

Trachtenberg, Alan, ed. *Classic Essays on Photography*. New Haven: Leete's Island Books, 1980.

Trachtenberg, Alan. *Reading American Photographs: Images as History, Mathew Brady to Walker Evans*. New York: Hill and Wang, Division of Farrar, Staus & Giroux, 1990.

Vanderwood, Paul J. and Frank N. Samponaro. *Border Fury: A Picture Postcard Record of Mexico's Revolution and U.S. War Preparedness, 1910–1917*. Albuquerque: University of New Mexico Press, 1988.

POST CARD

CORRESPONDENCE HERE

THIS SPACE FOR ADDRESS ONLY

ADDRESS ONLY

Mrs Watson
Wooster
Ohio

Miss Katie Reedy
1969 Congress St.
Chicago Ill.

U.S. POSTAGE
ONE CENT

Frank H. Sheldon
819 Wisconsin St.
Huron
Dak.

This is ... burg
dont you think it is
growing, we got home
safe but awful slow
Your Friend L. M. F.

Mr. Fred Myer
Bangor
Me
No 10 Central St

Friend Fred we
Send this Card
with best of
regards